IMAGES
of America

GREEK-AMERICAN
PIONEER WOMEN OF ILLINOIS

On the cover is a photo of the Cretan women's group, the Amalthia Society, taken in 1930—the year the group was founded by Presbytera Petrakis.

IMAGES
of America

GREEK-AMERICAN PIONEER WOMEN OF ILLINOIS

THE STORIES OF GEORGIA BITZIS POOLEY,

PRESBYTERA STELLA CHRISTOULAKIS PETRAKIS,

THEANO PAPAZOGLOU MARGARIS,

VENETTE ASKOUNES ASHFORD,

AND SENATOR ADELINE J. GEO-KARIS

The Greek Women's University Club
Editor: Dr. Elaine Cotsirilos Thomopoulos

Contributors: Dr. Nicholas Askounes Ashford, Vivian Margaris Kallen,
Alice Orphanos Kopan, Dr. Andrew T. Kopan,
and Dr. Elaine Cotsirilos Thomopoulos

Adapted from the GWUC's photo exhibit "Greek-American Pioneer Women of Illinois."
The co-curators of this exhibit are Penny Sarlas and Elaine Cotsirilos Thomopoulos.

ARCADIA
PUBLISHING

Published by Arcadia Publishing
Charleston SC, Chicago IL, Portsmouth NH, San Francisco CA

Printed in the United States of America

Library of Congress Catalog Card Number: 00-107880

For all general information contact Arcadia Publishing at:
Telephone 843-853-2070
Fax 843-853-0044
E-mail sales@arcadiapublishing.com
For customer service and orders:
Toll-Free 1-888-313-2665

Visit us on the Internet at www.arcadiapublishing.com

CONTENTS

ACKNOWLEDGMENTS

The Greek Women's University Club is grateful to the editor of this book, Dr. Elaine Cotsirilos Thomopoulos, and to Penny Sarlas, who with Dr. Thomopoulos was co-curator of the exhibit upon which this book is based. The club appreciates those agencies and individuals who assisted in the funding of this book, including the Illinois Humanities Council, the National Endowment of the Humanities, the Illinois General Assembly, and the Foundation for Hellenic Studies.

Also, the Greek Women's University Club thanks the contributors listed below, the officers and members of the Greek Women's University Club, and others who have so generously contributed their time and talent to this book.

CONTRIBUTORS OF THE BIOGRAPHIES AND CAPTIONS
Dr. Nicholas Askounes Ashford, Vivian Margaris Kallen, Dr. Andrew T. Kopan, Alice Orphanos Kopan, Harry Mark Petrakis, Penny Sarlas, and Dr. Elaine Cotsirilos Thomopoulos.

PHOTO CREDITS
Georgia Pooley: Courtesy of Dr. Andrew T. Kopan, Joan Pappas, and Greek-American Community Services.
Presbytera Stella Petrakis: Courtesy of Dr. Andrew T. Kopan, James M. Mezilson, George Manta, Harry Mark and Diana Petrakis, Ellie Sikaras, Hellenic Museum and Cultural Center, and SS. Constantine and Helen Greek Orthodox Church of Palos Hills, Illinois.
Venette Askounes Ashford: Courtesy of Drs. Nicholas and Robert Askounes Ashford, and SS. Constantine and Helen Greek Orthodox Church.
Theano Margaris: Courtesy of Vivian Margaris Kallen.
Senator Adeline J. Geo-Karis: Courtesy of Senator Adeline J. Geo-Karis, Judy Peacy, Greek-American Community Services, and AHEPAN Magazine.

DESIGN AND LAYOUT
John Rabias

BOOK, EXHIBIT, AND PROJECT PLANNING COMMITTEES
Leah Alexopoulos, Sarantis O. Alexopoulos, Dr. Beatriz Badikian, Nancy Canellis, Emily Cotsirilos, Dr. George Christakis, Maria Doxas Constantinides, Ann Dervis, Amy Dres, Nicholas Eliopoulos, Steve Frangos, Demetra Giannis, Bernard and Kay Hiles, Barbara Javaras, Bessie Kallas, Dr. Louise Año Nuevo Kerr, Dr. Andrew T. Kopan, Dr. George Kourvetaris, John and Regina Kulidas, Eleny Ladias Lake, Jean Leontios, Anna Letsos, the late Dr. Fotios Litsas, Afrodite Matsakis, Karen McArdle, Gloria McMillan, Electra Milonas, Anna Kanellos Moreno, Theodora Kanellos Nicolandis, Danai Papaioannou, Helen Papanikolas, John Rassogianis, Penny Sarlas, Telis Sarlas, Eugenia Georgoules Seifer, Artemis Dagles Spellman, Marie Sussman, Electra Tarsinos, Dr. Elaine Cotsirilos Thomopoulos, Melina Thomopoulos, Dr. Nick Thomopoulos, Betty Topalis, Anna Tymoszenko, Georgia Vlahos, and Thalia Zane.

INTRODUCTION

Between 1885 and 1923, Georgia Bitzis Pooley, Presbytera Stella Christoulakis Petrakis, Theano Papazoglou Margaris, Venette Tomaras Askounes Ashford, and Senator Adeline J. Geo-Karis, the inspiring women featured in this book, immigrated to the United States. By exploring the lives of these five exceptional women, we learn how the early Greek-American immigrant women, shaped by the traditions of Greece, adapted to and enriched their new home—the United States of America.

These five, who settled in Illinois, exemplify the early immigrant pioneer women who struggled to make a better way of life in the New World and who blazed a trail for those who followed. The courageous women who immigrated to this country in those early years suffered from hardships in the *xeneetia* (strange land). Most did not know the language or customs and came from rural villages. The alien culture and crowded city environment bewildered them. Loneliness overwhelmed them, since they had left behind the loving support of family and friends in the "old country." They cried for loved ones; some feared they would never see them again. They struggled against the hardship of limited financial resources and faced cruel discrimination as foreigners. Yet these brave, spirited women triumphed over adversity and embraced their adopted country to become exemplary citizens.

The five women featured in this book redefined the role of women in the Greek community. They ventured outside of the traditional boundaries of *nikokeeres*, or housewives. Not just supporters or helpers of the men, they played major roles on their own, in some cases despite family and community opposition.

Intelligent, sensitive women, they cared about their community and touched the lives of thousands. These unique, creative women used their talents in the theater, education, politics, journalism, literature, religion, and social services to energize and organize the community. Through the leadership of these five women, the Greek-American community preserved the traditions of the old country, offered support to those less fortunate who were left behind in Greece, assisted others who had immigrated to the United States of America, and enriched their adopted country, the United States of America. The energy, dedication, and outstanding accomplishments of the five women inspired their generation and the generations that followed.

By Elaine Cotsirilos Thomopoulos, Ph.D.

THE GREEK WOMEN'S UNIVERSITY CLUB

The Greek Women's University Club was established in 1931. The organization evolved from a dedicated group of seven members to a substantial membership of women of Greek heritage. The mission of this organization is to promote education and to encourage the arts, literature, and sciences in the community.

From its inception, the Greek Women's University Club has given women of Greek descent academic scholarships totaling more than $100,000. Since 1989, the Greek Women's University Club has also invited young men and women of Greek descent from throughout the United States to compete in its annual music competition, which has been held at the Chicago Cultural Center.

Many worthy causes have been supported by the Greek Women's University Club, among them the provision of equipment to the University of Athens science laboratories after World War II; the sponsorship of needy children in Greece; and contributions to the Hellenic Foundation, the Greek-American Nursing Home Committee, Cooley's Anemia Research, and the Modern Greek Studies Program at the University of Illinois in Chicago.

The club's extensive "Greek-American Women in Illinois" project (consisting of a series of lectures, literary readings, panel discussions, an oral history project, an exhibit, and this book) is contributing to the documentation of the Greek experience. This project was funded in part through the Illinois Humanities Council, the National Endowment of the Humanities, the Illinois General Assembly, and the Foundation for Hellenic Studies.

The Greek Women's University Club has sponsored art exhibits and competitions, lectures, and music recitals. Social events have included receptions honoring and recognizing persons of Greek heritage for their outstanding achievements in the arts and sciences. Members of the Greek Women's University Club have achieved recognition in education, law, medicine, politics, business, and many other fields. Throughout the years, the Greek Women's University Club has fostered Greek heritage and rewarded excellence.

One

GEORGIA BITZIS POOLEY
(1849–1945)

BY ANDREW T. KOPAN, PH.D. AND
ALICE ORPHANOS KOPAN, M.A., M.ED.

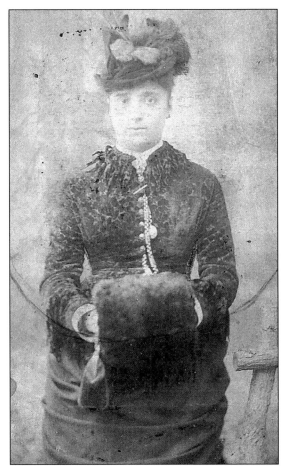

Georgia Bitzis Pooley, the first known Greek woman to immigrate to Chicago, played a vital leadership role amongst the early Greek immigrants of Chicago. Shortly after she came to Chicago in 1885, she began establishing philanthropic, religious, and educational organizations which laid the foundation for the present viable Greek-American community in Chicago.

Georgia Bitzis Pooley, the first known Greek woman to settle in Chicago, arrived with her husband Peter Pooley (Panagiotis Poulis) from the island of Corfu in 1885. Peter Pooley, a sea captain, traveled a few times via the Mississippi River to Chicago, where he became engaged in cargo transportation on Lake Michigan. In 1884, impressed with the employment and business opportunities of this growing Midwestern city, Captain Pooley went back to Corfu with the intention of finding a wife to bring back with him to Chicago. In Corfu, with the blessings of her family, he married Georgia Bitzis.

Georgia Bitzis was born in 1849. She was the third of seven children (two boys and five girls) of Alexander and Isabella Bitzis, who were established as a mercantile family in Corfu (ancient Corcyra), a prosperous and sophisticated island near the west coast of Greece in the Ionian Sea, which was for many years under Venetian control.

Georgia Bitzis' paternal grandfather had immigrated to Corfu from the province of Epirus on the Greek mainland in order to escape the hardships imposed by the Turkish authorities then occupying the area. In Corfu, he became a prosperous merchant and became involved in the movement to free the island from Venetian control. In 1798, Corfu passed from Venetian control to the French until 1815, when the Congress of Vienna awarded Corfu and the Ionian Islands to England following the Napoleonic wars. England ceded the islands to Greece in 1864.

Georgia Bitzis was educated at the academy in Corfu. She studied French, Italian, and English, as well as Greek. It was not usual for a Greek woman to have formal schooling at that time. Formal schooling was an elitist custom commensurate with the family's social position and wealth.

When Mrs. Pooley accompanied her husband back to Chicago in 1885, she was thirty-six years of age. She gave birth to the first of her seven children in 1886. The young family made their first home at Clark and Kinzie Streets near the Green Food Market, where the first Greek Town developed. Later they moved to Clark and Maple Streets near the present Annunciation Greek Orthodox Cathedral at 1017 North LaSalle Street. About 1902, they bought a home at 147 West Chicago Avenue (then numbered 222), where they lived for many years. Pooley ran a confectionery business next door to his home, at Chicago and LaSalle. Finally, after the death of Peter Pooley in 1914, the family moved to the Ravenswood area. In 1941, they moved to 4046 North Paulina Street, where Georgia Pooley died in 1945.

Awaiting Georgia Pooley when she arrived in Chicago was a Greek community composed of about one thousand males who had immigrated from their poverty-stricken homes in the rural villages of Greece. Most of the men were single and young, with a good number of youngsters barely over 14 years old. Many worked tediously long hours as laborers for little pay, ten to twenty living together, sharing the same rented rooms. Others were food peddlers who lived above smelly horse stables. They often shared the same bed, sleeping in shifts.

Pooley was appalled at their unsanitary living conditions. Also, she was concerned they did not have the moral restraints they would have had if they had remained in Greece, since they were without the support and influence of mothers, sisters, and the cohesive village community. Seeing the urgent need of these young men, Georgia Pooley determinedly organized the older Greek men and their non-Greek (mostly Italian and Irish) wives to help the young immigrants with their financial and social concerns. Feeling that religion would improve the morality of the men, Pooley persuaded these more mature family men to establish Greek Orthodox services. These men included Nicholas Peppas, George Brown (Kotakis), and Constantine Mitchell, who were among the earliest Greek settlers in Chicago. Because few Greek immigrants were in Chicago, Pooley convinced the Greek community elders to join forces with their fellow Eastern Orthodox Christians, the Russians and Serbians. Thus the Greco-Slavonic Brotherhood was formed in 1885. (Information about the 1885 formation of the Greco-Slavonic Brotherhood is found in the *Chicago Tribune*, 15 and 21 February 1897; *Chicago Daily Journal*, 22 April 1924; and *Greek Star* [Chicago], 9 April 1937. According to one source, a Greek house of worship was reputed to have been established in 1872. [Serpahim Canoutas, *Hellenism in America*, p.185 (in Greek)].)

The Brotherhood rented facilities in the 1700 block of North Clybourn Avenue on Chicago's north side. Traveling Serbian Orthodox and Russian Orthodox priests who spoke Greek were brought periodically to Chicago from distant areas to perform Divine Liturgy services and the

sacraments of baptism and marriage for the minuscule Orthodox Christian community.

In this respect, Pooley is reputed to be responsible for establishing the first house of worship and initiating the first Pan-Orthodox voluntary society in Chicago, until a purely "Greek" group called the Lycurgus Society supplanted it in 1891. This latter organization was the catalyst for establishing the first Greek Orthodox Church, the Annunciation, in 1892, originally at Randolph and Union Streets in Chicago. Later, after relocating to rented quarters on Clark and Kinzie Streets, it closed down in 1898.

Georgia Pooley, a dynamic, multilingual leader in the community, improved the education, social condition, and family life of the immigrants. She reached out to the Greek immigrant women who started to come to Chicago in the early 1900s. Even though they had little schooling and often were illiterate, they valued the education of their children and looked to Pooley for guidance and direction.

One of the main resources Pooley used was Hull House, established_by Jane Addams in 1889. After making acquaintance with Jane Addams, Pooley encouraged Greek-American families who had settled in the Greek Delta to utilize the recreational, educational, and health programs of nearby Hull House. The Greek Delta, a triangular-shaped neighborhood bordered by Halsted, Harrison, and Blue Island Streets, evolved into Chicago's Greektown. The Greeks were known to use the resources of Hull House more than the other ethnic groups. Their clubs were more numerous and attendance was larger. Many Greeks felt it was their own institution and attempted to monopolize it.

A group known as the Philoptochos Society of Greek Women (Friends of the Poor) was organized at Hull House in 1909. Pooley may have been a founding member of this group which met with the purpose of assisting indigent Greeks. The Philoptochos Society's twice-monthly meetings included lessons in English, Americanization, and European dancing.

The first Philoptochos Society at Hull House served as a model for the National Ladies Philoptochos Society, which in 1931 was organized by the Greek Orthodox Archdiocese of North and South America in New York City. In the Great Depression of the 1930s, Pooley and her friend, the late Presbytera Stella Petrakis of SS. Constantine and Helen Greek Orthodox Church on Chicago's south side, established Philoptochos chapters at many of the Greek Orthodox parishes in Chicago. Today, the National Ladies' Philoptochos Society is one of the largest women's philanthropic organizations in America.

With Pooley's encouragement and with the support of Jane Addams, the Hellenic League for the Molding of Young Men was formed at Hull House in 1910. The main purpose of this organization was the moral development of its members. Former non-commissioned officers of the Greek army drilled and trained the young men to prepare them to fight for Greece in the Balkan Wars, a condition which almost prevented Jane Addams from winning the Nobel Peace prize in 1931.

Pooley was a pioneer who ventured into areas which were previously taboo for Greek women. Women were expected to stay in the home! This is probably why she is not given credit for the establishment of the first Greek school in Chicago. She was a member of a "Committee of Family Leaders," the group that probably helped to found the Chicago Greek school during 1905–1906. Even though the school was in existence just a short time, it laid the basis for the establishment of Socrates in 1908, a parochial day school still in existence on the Northwest side of Chicago.

In later years, Pooley was deeply moved by the suffering of her countrymen in Nazi-occupied Greece during World War II. A dynamic leader even into her 90s, Pooley participated in the Greek War Relief Association which raised funds to help the homeless and starving in Greece. Until her death in 1945, Georgia Pooley was active in charitable endeavors in the Greek Orthodox community in Chicago.

Besides her activities in the community, Pooley was also very involved in raising her seven children, who were all born in Chicago over a period of fifteen years. The first two, Adele and Christos, died before the other children were born. Adele was born in 1886 when Mrs. Pooley was almost thirty-seven years of age. Her parents named her after her godmother, the English wife of the Greek consul. Christos was born in 1887. Next in line was Elizabeth who was born in 1888; she married Constantine Theodore and died childless in 1981. The next child, Harry,

born on February 12, 1890, became a musician, and served in the Navy during World War I and later entertained troops with the USO during World War II. He married Lillian Gustafson of Minnesota but died without children in 1973.

Another daughter, Katherine, born in 1894, married Themistocles Kannette (Kanetzios), and died in 1922, leaving two children, James Kannette and Helen Kannette (David) Wedel, the latter having no children. James Kannette married Eunice Brierley, and fathered two daughters—Jamie and Karol (Katherine). Jamie married Bernard Hurley and had no offspring. Carol married Dr. Walter Ray and became a mother to two daughters—Brierley and Denise—making them fifth generation descendants of the Pooleys. Denise has a boy named Kevin, the sixth generation of the Pooleys. Georgia Pooley's sixth child, Alexander (named after his maternal grandfather), was born in 1896. He attended Northwestern University and was one of the founders of the WAA-MU, a show which still exists as a student-produced musical. He became one of Chicago's first Greek dentists. He died a bachelor on September 9, 1935. Grief-stricken over Alexander's death, Pooley went to Greece in March of 1936 with her children, staying some eight months to recuperate from the death of her son.

At the late age of 50, Georgia Pooley gave birth to her last child, Mary, in 1899. In 1927, Mary married Peter Duris (Bouduris), and they had one child, Joan. DePaul University honored Mary Duris in 1985 as "Mother of the Year" at an annual Greek heritage program. The program observed the centennial of the arrival of the first Greek-American family in Chicago. Mary Duris died in 1998 at the age of 99.

Mary Duris' daughter Joan married Constantine Pappas, and they became the parents of two sons—Peter (1949), who married Cari Tsaoussis, and Trevon (1955), who married Rita Berk. Peter fathered two sons—Constantine (Dino), and Timothy. Trevon fathered a daughter, Carly, making them also fifth generation descendants of the Pooleys.

Duris' daughter Joan and her husband Constantine Pappas reside in Naples, Florida. Her grandson Peter and his family reside in Crystal Lake, Illinois, and her other grandson Trevon and his family live in Highland Park, Illinois. Thus, the granddaughters, Joan Pappas and the two Kannette girls, the Pappas boys, and the Ray girls (great-grandchildren), along with the fifth generation offspring of the Pappas boys and the Ray girl (great-great-grandchildren), and the son of Brierley Ray (great-great-great-grandchild and sixth generation offspring) are the only direct descendants extant.

Georgia Pooley died in Chicago on June 1, 1945 at age 96. Her husband preceded her in 1914 at age 70. Both are buried in the Greek Orthodox section of Elmwood Cemetery (Section 3B, Lot 91, Grave 4) close to the Greek Orthodox Chapel of the Holy Transfiguration, in suburban River Grove, Illinois.

In summary, Mrs. Pooley's educational background, comfortable upbringing, and socioeconomic status appear to have given her the self-confidence and impetus to venture outside the traditional role of the Greek woman as mother and housewife. She played a pivotal role in organizing the many germane organizations in the ethnic Greek community in order to reach out to those who were less fortunate. She established philanthropic, religious, and educational organizations which laid the foundation for the present viable Greek-American community in Chicago.

SELECTIVE BIBLIOGRAPHY

Information on Georgia Pooley is to be found in the following sources: *Chicago Tribune*, 15 and 21 February 1897, *Chicago Daily Journal*, 22 April 1924, and *Greek Star* (Chicago), 9 April 1937; Spyridon A. Kotakis, *E Hellenes en Ameriki* (*The Greeks in America*, 1906); Seraphim A. Canoutas, *Hellenism in America or the History of the Greeks in America* (1918); *Forty Years of Greek Life in Chicago 1897–1937* (1937); and Basil T. Zoustis, *The Greeks in America and Their Activity* (1954) in Greek. In English are *Hellenism in Chicago* (1982), Melvin G. Holli and Peter d' A. Jones, Eds..; *Ethnic Chicago: A Multicultural Portrait* (1984 and 1995 editions); and Andrew T. Kopan, *Education and Greek Immigrants in Chicago 1892–1973: A Study in Ethnic Survival* (1990). Information on the Pooleys' genealogy has been procured by interviews with the surviving daughter, Mary Duris, in 1985 and granddaughter Joan Pappas in 1995 and 1996.

For a full bibliography see Andrew T. Kopan and Alice Orphanos Kopan, "Georgia Bitzis Pooley" in *Women Building Chicago 1770–1990: A Biographical Dictionary* (Bloomington: Indiana University Press, forthcoming), from which this article was adapted.

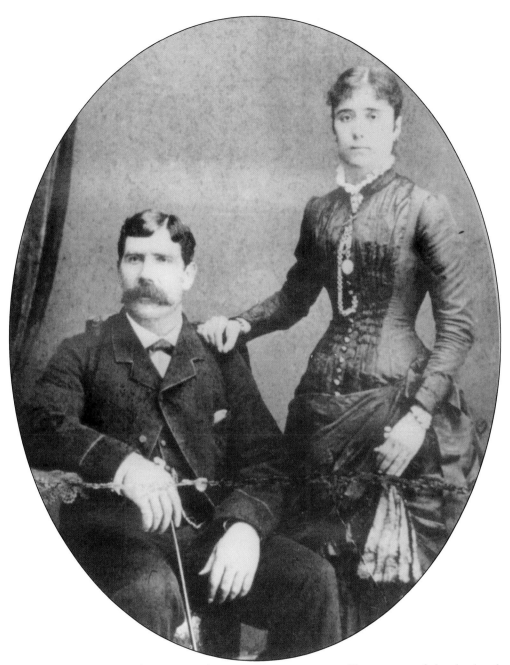

Georgia Pooley, the first known Greek woman to immigrate to Chicago, is with her husband, Peter Pooley, shortly after their arrival from Corfu, Greece in 1885. Mrs. Pooley helped organize the Greco-Slavonic Brotherhood. This organization initiated the first Eastern Orthodox house of worship in Illinois. Greek-speaking Russian and Serbian Orthodox itinerant priests held services in Chicago. (Andrew T. Kopan Collection.)

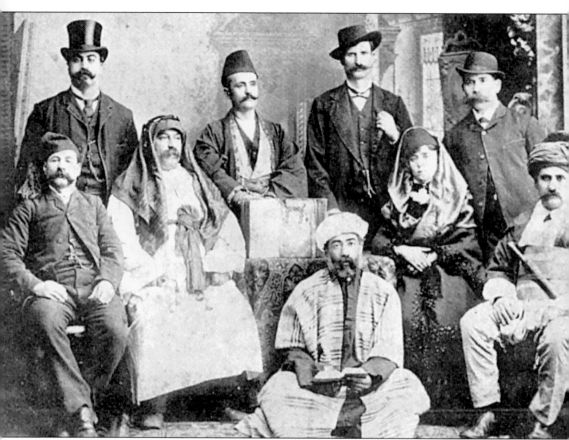

These early Greek immigrants in Chicago are apparently dressed for an *apokreatiko glendi* (Mardi Gras celebration). Georgia Pooley and her husband Peter are on either side of the table in the center. Note that she is the only woman. This was at a time, in the 1880s or 1890s, when Greek men greatly outnumbered Greek women in Chicago. (Andrew T. Kopan Collection.)

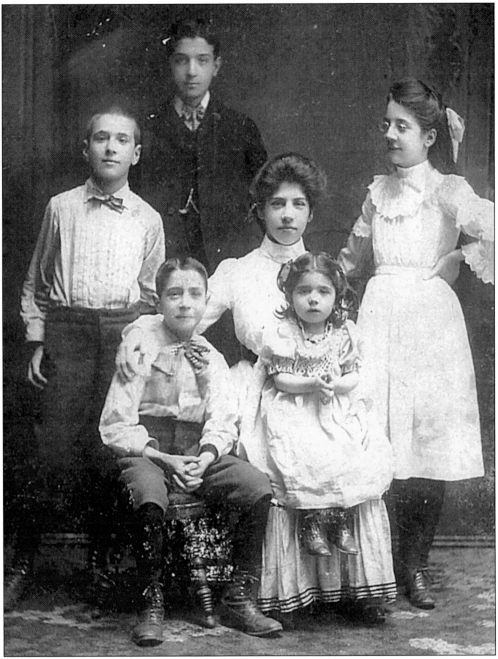

The Pooley children and their first cousin are in this c. 1901 photo. Pictured from left to right, wearing white clothes, are Harry, Alexander, Elizabeth, Mary, and Katherine Pooley. In the back, dressed in a dark suit, stands their first cousin Epaminondas De Silla, son of Mrs. Pooley's sister. He immigrated to Chicago from Greece when he was eighteen years of age and lived with the Pooley family for many years. His mother and the other Bitzis sisters remained in Greece. The Pooley family typifies other immigrant families of that time and into the present, as families (parents, children, grandchildren, sisters, and brothers) were and are separated by the vastness of the Atlantic Ocean. (Joan Pappas Collection.)

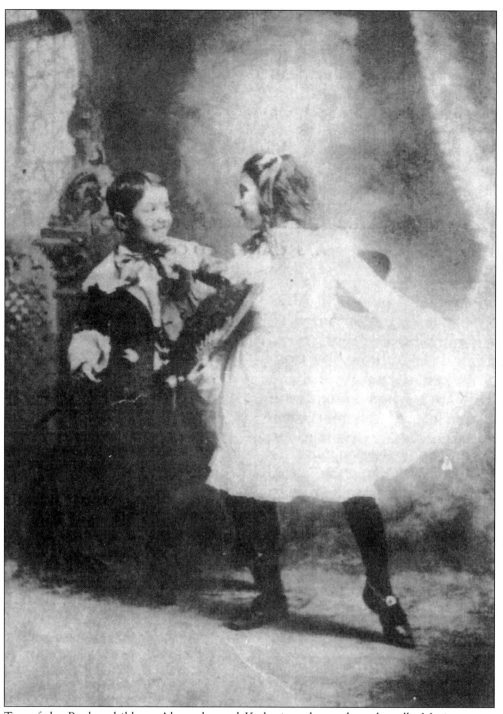

Two of the Pooley children, Alexander and Katherine, dance the cakewalk. Music was an important part of the Pooley's family life, according to Mary Duris, Georgia Pooley's daughter. Mrs. Pooley played the guitar. Two of her children, Harry and Elizabeth, played music professionally. Elizabeth, according to Mary Duris, played at the silent movies. Dr. Alexander Pooley and Mary Duris were also accomplished musicians. (Andrew T. Kopan Collection.)

82-Year-Old Volunteer
AIDS GREEK RELIEF FIGHT

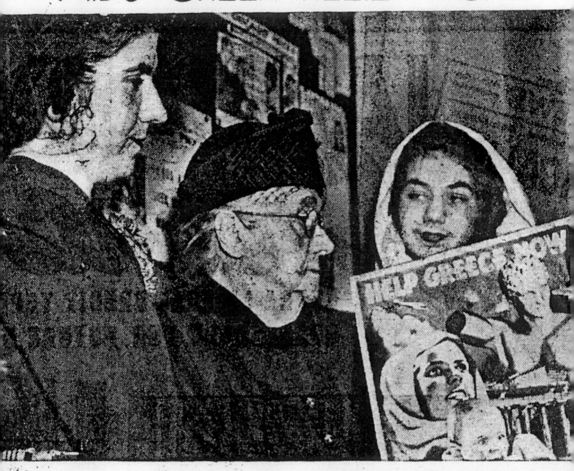

First Greek woman to enter the United States as an immigrant, Mrs. Georgia Pooley (center), 82, of 2046 Berteau av., enlists as volunteer worker in the Greek War Relief Association's campaign to raise $10,000,000 for sufferers in her native land. With daughter, Mary Duris (left), Mrs. P views campaign poster held by Duris, her granddaughter.

The caption of this photo from the *Chicago Herald-American*, April 1941, reads "First Greek woman to enter the United States as an immigrant, Mrs. Georgia Pooley (center), 82, of 2046 Berteau Avenue enlists as volunteer worker in the Greek War Relief Association's campaign to raise $10,000,000 for war sufferers in her native land. With her daughter, Mary Duris (left), Mrs. Pooley views campaign poster held by Joan Duris, her granddaughter." Although the caption says she is 82, since she was born in 1849, her correct age would have been 92 when this photo was taken. (Andrew T. Kopan Collection.)

17

Dr. Andrew T. Kopan is Professor Emeritus of Education at DePaul University in Chicago, with which he has been affiliated for over 30 years and which awarded him its highest honor, the Via Sapientiae Award. He previously served as a teacher and principal in elementary and secondary schools and also as Superintendent of Greek Orthodox Schools in the Diocese of Chicago. He holds degrees from DePaul, Northwestern, and the University of Chicago as well as an Honorary Doctor of Letters degree from Hellenic College/Holy Cross School of Theology. He is an Archon of the Ecumenical Patriarchate of Constantinople (the world center of the Greek Orthodox Church), with the honorific Byzantine title of "Teacher of the Nation." He has taught and served as educational consultant in England, Greece, and Israel. Specializing in multicultural education and Greek immigration studies, he has served on federal and state educational commissions. His awards for ethnic scholarship include those from the White House Conference on Education, the Illinois State Office on Multiculturalism, the University of Texas, and Yeshiva University in New York. As a recognized authority in his areas of specialization he has contributed over 2,800 articles in the metropolitan and ethnic presses, 300 monographs and journal articles, and has authored 16 books. Among them are his prize-winning chapter on "Greek Survival in Chicago," in *Ethnic Chicago: A Multicultural Portrait* (1977, 1981, 1984, 1995); *Education and Greek Immigrants* in Chicago, 1892–1973 (1990); "The Greek Press in America," in *The Ethnic Press in the United States* (1987); *Rethinking Urban Education* (1972); *Education and Cultural Pluralism* (1970); and "Multicultural Education" in *Dictionary of American Immigration* (1990). His most recent contributions will appear in *Women Building Chicago 1770–1990: A Biographical Dictionary* (forthcoming), and the entry on Greeks in the soon to be published *Chicago Encyclopedia*.

Alice Orphanos Kopan is a certified administrator, educator, and family and consumer sciences specialist. She is also a co-author of a long-time, best-selling educational textbook for secondary school students which is used in American schools worldwide. She has co-authored, together with her husband, Andrew T. Kopan, articles on Georgia Bitzis Pooley and Presbytera Stella Christoulakis Petrakis in *Women Building Chicago 1770-1990: A Biographical Dictionary* (forthcoming). She holds a B.S. degree from Illinois Institute of Technology; a M.Ed. from the University of Illinois, Urbana (magna cum laude); and a M.A. from DePaul University, Chicago (magna cum laude). Alice has done post-graduate work as a fellow at the Wharton School of Finance at the University of Pennsylvania and is a John Hayes Fellow recipient. She also was a recipient of a teaching fellowship at the University of Illinois, Urbana.

Mrs. Kopan has served as a city supervisor of the Chicago Public Schools, North Central Association Accreditation Coordinator, adjunct assistant professor of Rosary College (Dominican University), and supervisor of student teachers at DePaul University and Rosary College. She has written extensively for advertising agencies and has developed a wide variety of educational materials for school systems and publishing firms. Mrs. Kopan has been actively involved as an officer and member of many professional and church-related organizations for decades at the national, state, and local levels.

Two

Presbytera Stella Christoulakis Petrakis (1888–1979)

by Elaine Cotsirilos Thomopoulos, Ph.D.

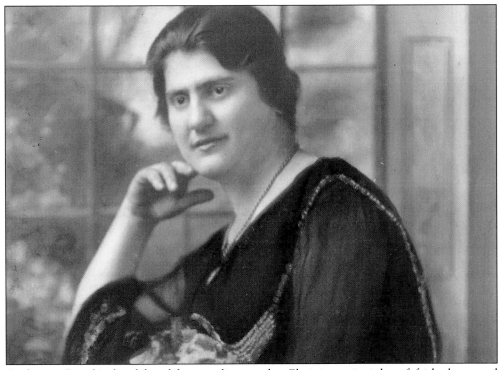

Presbytera Petrakis lived her life according to the Christian principles of faith, love, and hope, and had an extraordinary drive and ability to serve others. She organized philanthropic institutions, which continue her labor of love today. The late Ecumenical Patriarch Athenagoras of Constantinople, world head of the Greek Orthodox Church, spoke of her career as "a unique act of unselfish love."

Presbytera Stella Christoulakis Petrakis was born on May 8, 1888 in the village of Nipos near the city of Chania on the island of Crete, which was then under Turkish rule. She was the daughter of Charalambos Christoulakis, a teacher at the local high school, and Irene Katsandreakis. Because their three earlier children unfortunately died as infants, when their daughter was born she was dedicated to St. Stylianos, patron saint of infants. She was named Styliane (Stella). She had two younger sisters, who remained in Greece after she immigrated.

After attending a teacher's school in Chania, she married on February 19, 1908, when she was only 19 years old. She married her husband, Rev. Mark E. Petrakis, a week before he was ordained into the priesthood. In the Greek Orthodox Church, a priest is permitted to marry as long as he is married prior to ordination. After her husband became a priest, Stella Petrakis was referred to as Presbytera, the title given to the wife of a priest. Rev. Petrakis was assigned to serve in Crete, where he remained until 1916. Presbytera Petrakis gave birth to four children in Crete; another two children were born after they had immigrated to the United States. In Crete, she helped Greek refugees who had been forced by the Turkish government to flee from their ancestral homes.

In 1916, the Petrakis family came to the United States after the young Greek Orthodox immigrants from the coal mining community of Carbon County, Utah requested the assignment of Rev. Petrakis to their parish. According to their son, Harry Mark Petrakis, the couple decided to journey to America so that their children would have the advantage of an American education. In May of 1916, the family of six made the difficult journey (amidst the threat of menacing German U-boats) from Crete to the U.S.A. When they arrived at Ellis Island, the church official from Carbon County, Utah had not yet arrived to receive them. They were forced to spend a miserable night on Ellis Island. As was customary on Ellis Island at that time, families were separated, with men going to one section and women to another.

The next day, they began the long journey to Salt Lake City by train, accompanied by a parishioner. From Salt Lake City they rode approximately 120 miles by car to the coal mining community of Price. Presbytera Petrakis' son, Harry Mark Petrakis, in *Tales of the Heart, Dreams and Memories of a Lifetime* describes their arrival:

> In the railroad station in Salt Lake City, my family was met by a multitude of almost one thousand miners who had come from towns as far as one hundred miles away to greet them with a celebratory thunder of gunshots fired into the air.
>
> In later years my mother spoke of being terrified by the gunfire, worrying about the barbaric society her family was entering. Then she descended from the train with my sisters in their lace-fringed white dresses, and a reverential hush fell over the assembled men, who had not seen a Cretan woman or Cretan children since leaving their island. Men knelt and prayed in gratefulness, and some wept and reached gently to touch the hem of my mother's dress as she passed.

(From *Tales of the Heart*, copyright 1999 by Harry Mark Petrakis, by permission of Harry Mark Petrakis and Ivan R. Dee, Publisher.)

While Rev. Petrakis organized the new parish of the Assumption Greek Orthodox Church, Presbytera Petrakis also put her talents to work by forming an American Red Cross unit for women of the parish and selling Liberty Bonds for World War I.

The young single men of the parish, most of whom were without family, were indebted to her for her motherly support. Presbytera Petrakis reported to Dr. Andrew T. Kopan that when the miners came out of the mines, she and other women of the parish would boil their filthy clothes in big cauldrons over open fires.

In 1919, Rev. Petrakis was assigned to the parish of St. Paul Greek Orthodox Church in Savannah, Georgia and in 1921, he was assigned to St. Nicholas Greek Orthodox Church in St. Louis, Missouri. At these parishes, Presbytera Petrakis continued organizing Red Cross units and women's philanthropic groups such as Elpis in St. Louis. She also participated in and organized dramatic presentations.

At SS. Constantine and Helen Greek Orthodox Church in Chicago, where Rev. Petrakis was assigned in 1923, Presbytera founded many church programs and organizations, including

the St. Helen Philoptochos Society, the Koraes School Mothers' Club, the afternoon Greek religious classes, the St. Constantine Red Cross Unit, and Nea Genea (an organization for young single women later reorganized as Agia Paraskevi). She continued directing dramatic presentations with religious or patriotic themes.

A short, dynamic whirlwind of energy, Presbytera Petrakis organized the Amalthia Chapter of Cretan Women in Chicago. In the 1930s, she was on the Board of Directors of the United Greek Charities of Chicago, a philanthropic organization that helped needy families during the Great Depression. The various organizations in the Chicago area, (including the Greek Orthodox churches, American Hellenic Educational Progressive Association (AHEPA), Greek-American Progressive Association (GAPA), Masonic Lodge, Professional Men's Association, Young Ladies Hellenic Societies, newspapers and magazines, the athletic club, trade associations, and social organizations) joined forces in this worthwhile effort.

Harry Mark Petrakis, in his book *Reflections*, describes his mother:

> She had a quick, lilting voice, full of ripples, breakers, and billows and flecked with a wry penetrating humor. . . For a small woman, my mother had an incredible abundance of energy and strength. A certain rampant force of life within her drove her forward. She had no fear of the before and the after, of the above and the below, of this world, of the world to come. Her faith was the wellspring from which she drew certainty. She believed firmly that God held the earth in His eyes. Using her faith as a compass, she charted the undeviating course of her life. All roads led to service.

> She founded, directed and helped sustain numerous organizations within the parish. Given a block of tickets for a community raffle or picnic, she outsold everyone else, disposing of the pile with equanimity to willing and unwilling purchasers. Storekeepers fled out the rear doors when they saw her entering. They need not have bothered, because she would invariably return. A strong believer in the parity of religions, she did not solicit ads for a church program book from Christian alone, but adeptly canvassed Jew, Moslem and agnostics as well. In the areas outside the church, she worked like a zealot for the Red Cross, Community Fund, Interfaith group, and hospital auxiliaries.

> Her most ingenious efforts involved helping individuals whose suffering and misfortunes had been overlooked by the church or social agencies. She developed a network of women across the city that brought these cases to her attention. For one crippled old man she gained admission into Oak Forest, the county home. For an ailing mother with young children she obtained regular delivery of free bread, eggs, butter and milk. For an old woman without any means of support she obtained a pension. For another woman, whose son had been caught in an attempted robbery, she procured legal counsel for the boy and appeared herself as a witness on his behalf.

> There were also times my mother was called upon to act as a marriage broker, a role she played with artful cunning and delight. She approached each connubial crucible as if the survival of the race depended upon her making the match. When she managed to bring a man and woman together, her only reward, usually, was the gratefulness of the parents and, sometimes, being asked to become godmother to the couple's first child. After many years of successful matchmaking, my mother had two score children calling her 'Nouna.'

(From *Reflections*, copyright by Harry Mark Petrakis, Lake View Press, Chicago; by permission of Harry Mark Petrakis.)

This description by Harry Mark Petrakis shows how Presbytera Petrakis lived frugally and simply:

> She, the wife of a poor parish priest, was forever scraping and scrimping to provide her children with whatever they needed for school and work. She never went to a beauty shop in her life; she washed her long hair at home, and brushed it and then tied it up into a bun. Her dresses and hats were purchased for their utilitarian value. She wore them until they wore out, heedless of any innovation in the world of fashion.

(From *Tales of the Heart*, copyright 1999 by Harry Mark Petrakis; by permission of Ivan R. Dee, Publisher, and Harry Mark Petrakis.)

During World War II, Petrakis was a leader in the Greek War Relief Association. She also sold defense bonds and founded and headed the Greek-American Star Mothers, a hard-working group which prepared and sent food and gift parcels to Greek-American servicemen and servicewomen. Besides all this, she worked in a factory making ammunition. Harry Mark Petrakis, in *Tales of the Heart*, describes her hectic life at that time:

> She worked the night shift from midnight to 7 a.m., and I remember waking in the early morning about the time she returned wearily home. She did not lie down to sleep but washed and changed her clothing and started the activities of her day. This overly ambitious regimen came to an end when, after being warned several times by the shop foreman, she was discharged for recurringly falling asleep at her bench. My mother indignantly denied that accusation, but I suspect the grievance of her foreman was true. She had to sleep somewhere.

(From *Tales of the Heart*, copyright 1999 by Harry Mark Petrakis; by permission of Ivan R. Dee, Publisher, and Harry Mark Petrakis.)

In 1951, her husband of 43 years, Rev. Mark Petrakis, died. After his death (as described by her son Harry Mark Petrakis in his book *Reflections*), Presbytera earned a meager living selling *kolivo*, the boiled wheat that is distributed at Greek Orthodox funerals in memory of the deceased. Her daughter-in-law, Diana, helped in the preparation of the *kolivo* and her son, Harry Mark, reluctantly made the deliveries to SS. Constantine and Helen Greek Orthodox Church, the church his father had so proudly served prior to his death.

She continued her activities in the church organizations and during the 1950s and 1960s she was active in the Chicago Justice for Cyprus Committee and the Immigrants' Service League, together with Venette Askounes. She also was involved in non-Greek organizations, including Mayor Daley's Civic Committee, the South Shore Interfaith Women's Group and was a volunteer at local hospitals.

Her philanthropic activities were world-renowned. The late King Paul of Greece awarded her the Gold Cross of King George I. She also received commendations from Eleftherios Venizelos, the Prime Minister of Greece (1914), from the martyred Metropolitan Chrysostom of Smyrna (1920), and from Archbishop Meleletios of Athens (1920). Several other international agencies, including the Near East Philanthropic Association (1922), also honored her.

In the United States, President Truman awarded her a citation for her war efforts. The American Red Cross honored her for 50 years of continuous service. In 1960, she received an award from the Immigrants' Protective League and in 1962 the Greek Orthodox Women's Philoptochos Society named her Women of the Year. Archbishop Iakovos awarded her the St. Paul Medal in 1974.

On May 7, 1979, Presbytera Stella Petrakis died, one day shy of her 91st birthday. She had contributed immeasurably to the community, while still finding time to raise six children. Her children were Dan, Barbara Manta, Tasoula Thoman, Manuel, Harry Mark (the renowned chronicler of the Greek-American experience), and Irene. She is survived by Manuel and Harry Mark. Fourteen grandchildren and numerous great-grandchildren also survive her.

Presbytera Petrakis lived her life according to the Christian principles of faith, love, and hope, and had an extraordinary drive and ability to serve. She organized numerous philanthropic institutions, which today continue her "labor of love" legacy. The late Ecumenical Patriarch Athenagoras of Constantinople, world head of the Greek Orthodox Church, spoke of her career as "a unique act of unselfish love."

SELECTIVE BIBLIOGRAPHY

The information in this essay and the captions are primarily based on the research of Prof. Andrew T. Kopan, Ph.D., and his book: *Education and Greek Immigrants in Chicago 1892–1973: A Study in Ethnic Survival* (New York: Garland Publishing, 1990), his article in the *Greek Star* (June 14, 1979), his lectures given at SS. Constantine and Helen Greek Orthodox Church, Palos Hills on March 18, 1997 and at Assumption Greek Orthodox Church, Chicago on

May 31, 1998, and the biographical entry by Andrew T. Kopan and Alice Orphanos Kopan, entitled "Stella Chrisoulakis Petrakis" in *Women Building Chicago 1770–1990: A Biographical Dictionary* (Bloomington: Indiana University Press, forthcoming) from which this article was adapted. Other sources include the *75th Birthday Celebration Program Book of the Greek Orthodox Church of the Assumption of the Blessed Virgin Mary*, (Price, Utah: Greek Orthodox Church of the Assumption of the Blessed Virgin Mary, 1991); *Elpis 25th Anniversary Celebration Program Book*, (St. Louis, Missouri: St. Nicholas Greek Orthodox Church, 1945); *SS. Constantine and Helen Greek Orthodox Church Diamond Jubilee Program Book*, (Illinois: SS. Constantine and Helen Greek Orthodox Church, Illinois, 1985); interviews in 1999 and 2000 with James M. Mezilson, Harry Mark Petrakis, and Fay Machinis; and original correspondence and newspaper clippings made available through Harry Mark Petrakis and James M. Mezilson. The quotations are from Harry Mark Petrakis, *Reflections* (Chicago: Lake View Press, 1983, 29, 30 copyright by Harry Mark Petrakis, by permission of Harry Mark Petrakis); and from Harry Mark Petrakis, *Tales of the Heart, Dreams and Memories of a Lifetime* (Chicago: Ivan R. Kee, 1999, 7, 63, 64, 66, 67 copyright 1999 by Harry Mark Petrakis, by permission of Harry Mark Petrakis and Ivan R. Dee, Publisher).

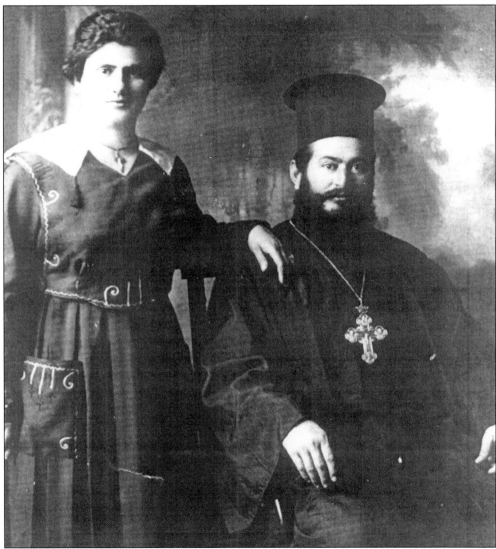

Presbytera Stella Petrakis is pictured here with her husband, Rev. Mark E. Petrakis, in 1916, the year they arrived in the United States. Rev. Petrakis' first assignment was in Carbon County, Utah where he organized the church for this coal mining community. The community specifically requested the assignment of Reverend Mark Petrakis from the Holy Synod of Greece.

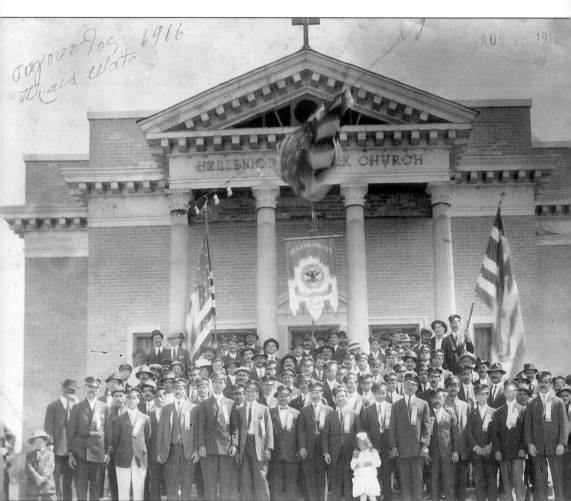

The consecration of the Hellenic Orthodox Church (renamed the Assumption of the Virgin Mary) of Price, Utah took place in August 1916, shortly after the arrival of the Petrakis family. According to the *75th Birthday Celebration Program Book of the Greek Orthodox Church of the Assumption of the Blessed Virgin Mary*, "Special trains ran from the coal camps bringing the men and what few women and children there were to Price for the celebration shortly after the church was built. The community was comprised primarily of young Greek men from the island of Crete and the province of Roumeli, north of Athens." The men wearing hats and badges are members of the Hellenic Society (as indicated by the banner). They accomplished their purpose of building a church. Only two women (in fourth row) are pictured. There are two children in the photo, a boy and girl in the front row.

This dignified photo of Presbytera Petrakis was taken in 1914 by Kalletechnikon Photography of Greece.

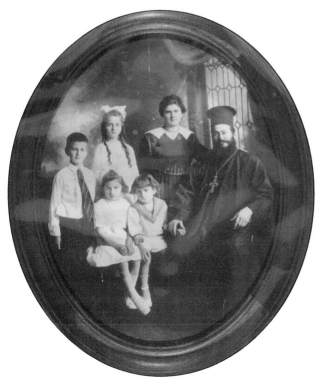

Presbytera Stella Petrakis is shown here with her husband and four children in 1916. The children, standing from left to right, are Dan and Barbara. Those seated are Tasula and Manuel. These four eldest Petrakis children were born in Crete. Two other children, Harry Mark and Irene, were born in the United States. A volley of gunfire shot into the air welcomed the Petrakis family upon their arrival by train in Salt Lake City.

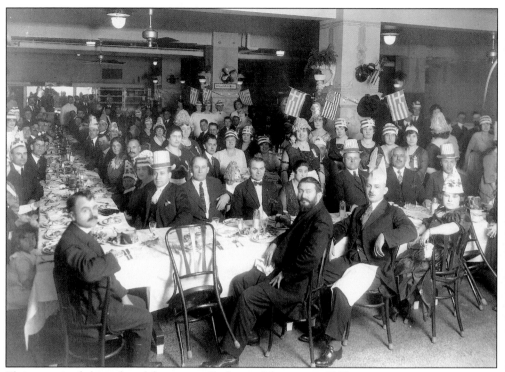

Elpis organized this gala celebration in St. Louis, Missouri in 1923.

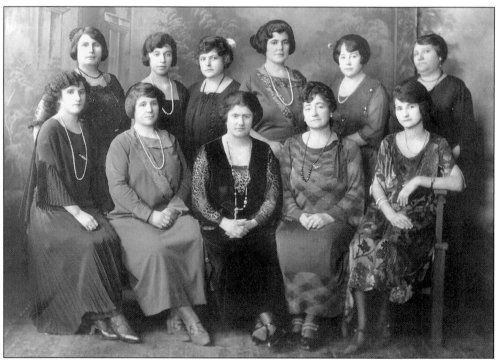

These women, dressed in their finery, are members of the Greek Ladies Benevolent Society Elpis.

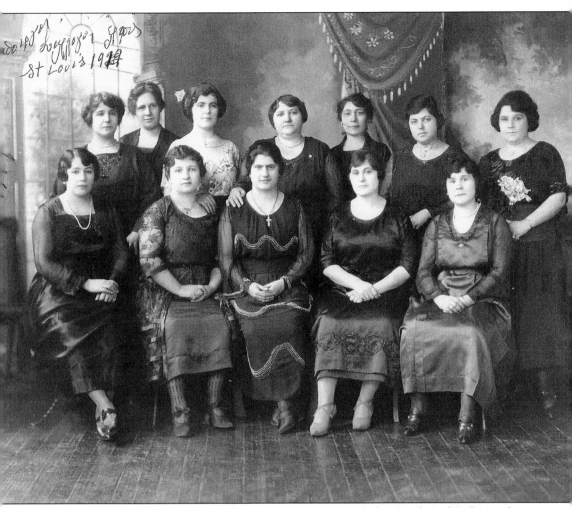

In St. Louis, Missouri, in 1920, Presbytera Petrakis organized the Greek Ladies Benevolent Society Elpis (Hope). It is still in existence at St. Nicholas Greek Orthodox Church. They had as their standard the virtues "Faith, Hope and Love." According to the description given in the *Elpis 25th Anniversary Celebration Program Book*, "They visited brother Greeks who were confined in hospitals and who had not heard a Greek voice for many years. They comforted the dying, who far away from their home and loved ones, saw in the kind ministrations of the members of the Elpis the personal consideration that would have been given by their own beloved. They gave a helping hand to widows and orphans. They cheered by work and deed the unhappy and needy. They helped of funeral expenses for the unfortunate. They did everything that was humanly possible for the poor, needy and unfortunate as far as their means would permit."

As indicated in the *Anniversary Celebration Program Book*:

In the first row are Mrs. K. Kiourtsis, M. Anastas, Presbytera Petrakis, K. Angellits, M. Kanias. In the second row are Mrs. P. Cassimatis, Helen Avouris, M. Tombras, Stav. Fanelis, P. Bastardis, K. Actepy, and Helen Mandelaris.

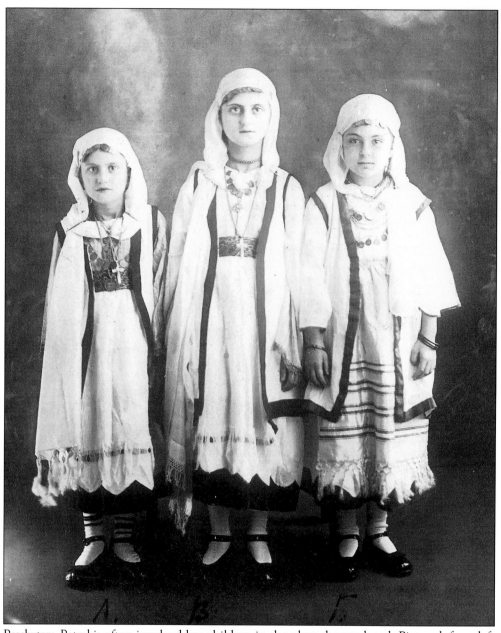

Presbytera Petrakis often involved her children in the plays she produced. Pictured, from left to right, are her daughters Tasula and Barbara, and their friend Katina Mamalakis. This photo was taken in St. Louis, Missouri *c.* 1921.

Presbytera Petrakis enjoyed and excelled in acting and directing plays. In 1921, she appeared in this performance in St. Louis, Missouri presented by Elpis. She is on the left in the photo of three women. To her right are Maria Cassimatis and M. Tombras.

This photo of Presbytera Petrakis dates from 1921.

In the 1920s, The Hellenic Ladies Society of Elpis (Hope), like many of the women's clubs in America at that time, was active socially and politically. Presbytera Petrakis, president of Elpis, sent a letter to the Honorable Harry B. Hawes protesting the proposed immigration law restricting immigration from the Balkans and Southern Europe. He responded with this letter dated March 27, 1923. He notes that he was one out of 33 of 430 members of the House who voted against this bill.

HARRY B. HAWES
11th Dist. Missouri

Congress of the United States
House of Representatives
Washington, D. C.
March 27, 1922.

Miss Stella M. Petraki,
President, Hellenic Ladies Society Helpis,
c/o Hellenic Publishing Co.,
302 N. Third St.,
St. Louis, Mo.

My dear Miss Petraki:

Your interesting letter of March 18th received.

I agree with you in regard to the immigration laws. I was one out of 33 of 430 Members of the House who voted against this bill.

All of our ancestors came from foreign countries; some from England, some from France, some from Germany, Italy and Greece. We have built up a great nation and I do not think the time has come to shut the door now.

Of course, there are some bad people that come in, but this could be prevented on the other side.

Recently, when this matter again came before the House, I voted to admit those immigrants who were then being detained at Ellis Island.

There should be some changes in our immigration laws, but the recent provisions have been too drastic and too exclusive.

The Immigration Committee is controlled by Republican members of that committee, and whatever they decide upon will be done. The average Member of the House will have little to say, but if the subject is reported by the committee and comes before me for a vote, it will have my very careful consideration.

I shall forward your communication to the Chairman of the Committee on Immigration, and trust it may have good effect.

Yours very sincerely,

Harry B. Hawes

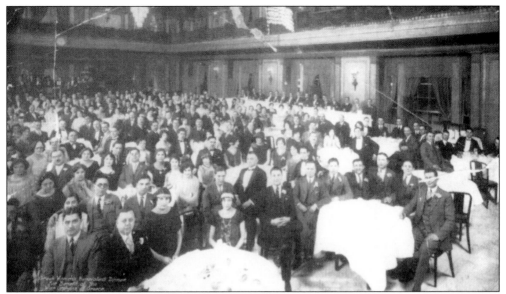

In 1923 Presbytera Petrakis accompanied her husband to Chicago, where he was assigned to SS. Constantine and Helen Greek Orthodox Church. She founded the St. Helen's Benevolent Society at this church in 1924. They organized this gala at the Morrison Hotel, Chicago, on May 25, 1925 to benefit the war orphans of Greece.

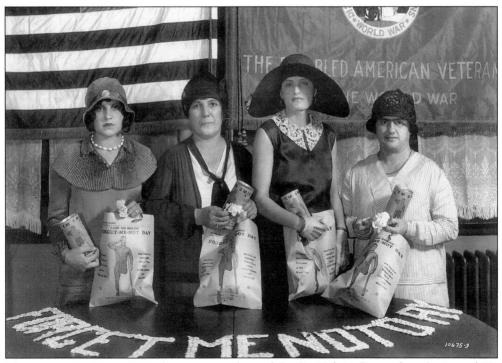

The women in this c. 1927 photo are members of the St. Helen's Benevolent Society of SS. Constantine and Helen Church in Chicago. Their president, Presbytera Petrakis, is on the right. They assisted in the sale of "forget-me-nots" for the Edward Hines Jr. Chapter of the Disabled American Veterans of the World War. (Burke and Koretke photo.)

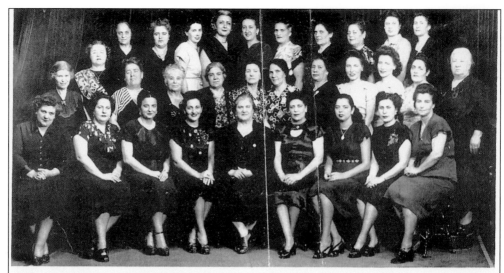

Presbytera Petrakis sits in the front and center of this photo of the Cretan Ladies Fraternity Amalthia. She founded this organization.

These elegant women are members of the Cretan women's group. Founder Presbytera Petrakis, with the black dress, sits in the middle, c. 1930.

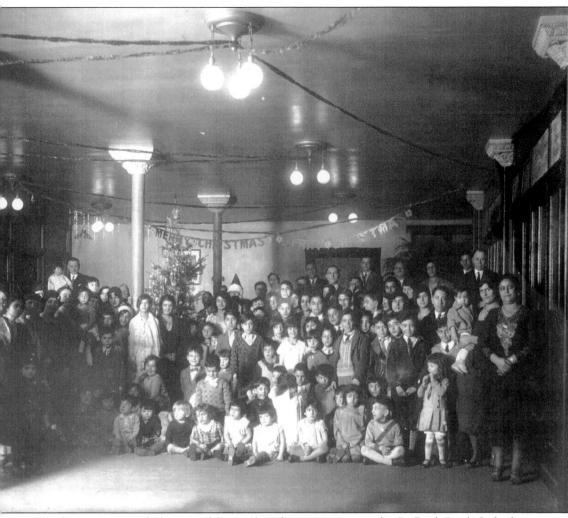

The Cretan Society of Chicago celebrates their first anniversary at the St. Basil Greek Orthodox Church's basement at 733 S. Ashland, Chicago, c. 1931. Presbytera Petrakis stands near the post in the back under the Christmas tree and is wearing the dark dress.

UNITED GREEK CHARITIES OF CHICAGO
SUITE 2414, ONE NORTH LA SALLE STREET
TELEPHONE STATE 2704
CHICAGO, ILLINOIS

EXECUTIVE COMMITTEE
A. GEORGE N. SPANNON, CHAIRMAN
C. A. SOTTER, VICE-CHAIRMAN
C. MAMMON, TREASURER
ARTHUR H. PEPONIS, SECRETARY
MISS ALEXANDRA CALOIDA,
EXECUTIVE SECRETARY

DIRECTORS
MRS. ALEXANDRA COKINS
MR. PAUL DEMOS
MISS. CARRIE MITCHELL
MRS. ALEXANDRA NIKOLETSEAS
MR. NICK KANELIS
MRS. STELLA PETRAKIS
MR. JOHN KOLIOPOULOS
MR. APOSTOLOS FLAMBOURAS
MR. GEORGE COKINS
MR. D. J. CHRISSIS

SPONSORED BY
AHEPA CHAPTERS
GAPA LODGES
GREEK AMERICAN ATHLETIC CLUB
HELLENIC MASONIC LODGE
HELLENIC POST AMERICAN LEGION
HELLENIC LODGE K. OF P.
LAUNDRY MENS ASSOCIATION
PROFESSIONAL MENS ASS'N
RESTAURANT KEEPERS ASS'N

GREEK ORTHODOX CHURCHES
ASSUMSION
HOLY TRINITY
KIMISSIS THEOTOKOU
ST. ANDREWS
ST. BASIL
ST. CONSTANTINE
ST. DEMETRY
ST. GEORGE
ST. NICHOLAS
ST. SPIRIDON

GREEK LADIES CHARITABLE AND EDUCATIONAL SOCIETIES
ASSUMSION
EUSEVIA
KIMISIS THEOTOKOU
ST. ANDREWS
ST. BASIL
ST. CONSTANTINE
ST. DEMETRY
ST. GEORGE
ST. NICHOLAS
ST. SPIRIDON

YOUNG LADIES HELLENIC SOCIETIES
GRECIAN MAIDENS
HELLENIC YOUTH
NEA GENEA
PHILOMUCICAL

NEWSPAPERS AND MAGAZINES
THE ARCADIA
THE AMERICAN HELLENIC HOME JOURNAL
THE DEMOCRAT
THE GREEK DAILY
THE GREEK PRESS
THE GREEK STAR
THE SALONIKI

SOCIAL ORGANIZATIONS
ARGITON
ASIA MINOR CLUB
COSMITON
CRETON
EPIDAVROU LIMIRAS
GERAKITON
KAREA
KASTRITON ST. GEORGE
KASTRITON TANIAS
LANGADIOTON
LEVIDIOTON
LOUKAITON
MESSINIA
NEOS SKOPOS
PSAREON
TEGEATIC LEAGUE
TRIPOLITON
VASARA
VALTETSIOTON
VLAHERNA
VRONTAMITON

January 6, 1931.

Mrs. Stella Petrakis, Pres.,
St. Helen Ladies Society,
423 East 60th St.,
Chicago, Ill.

Dear Madam:

Herewith enclosed you will find official receipt for the contribution of the St. Helen Ladies Society to the United Greek Charities of Chicago, which was received sometime ago. Please excuse us for not acknowledging same more promptly, due to the fact that we have been very busy organizing the Charities so as to function properly.

At this time let me enlighten you with the following facts concerning the United Greek Charities of Chicago. Up-to-date we have collected $3021.59 and have distributed to 124 families the sum of $1669.00 in weekly allowances. Also, through the efforts of the officers of this organization and the willingness of a number of our people, who have contributed in provisions, we have distributed 159 Christmas baskets to the needy ones. We are in hopes that we will be able to continue the weekly allowances and the distribution of food and clothing, provided however, that our people will come forth and do their share in contributing as much as possible.

In behalf of the United Greek Charities of Chicago we wish to thank you, and through you the officers and members of your organization for your contribution and co-operation in helping the needy ones.

Yours very truly,

UNITED GREEK CHARITIES OF CHICAGO.

Secretary.

Presbytera Petrakis served on the Board of Directors of the United Greek Charities of Chicago, an organization consisting of 61 Greek-American member organizations including churches, the media, and trade, social, charitable, and educational organizations. This letter, dated January 6, 1931, thanks St. Helen's Ladies Society for its contribution to the fund used to give cash allowances and baskets to families during the Great Depression.

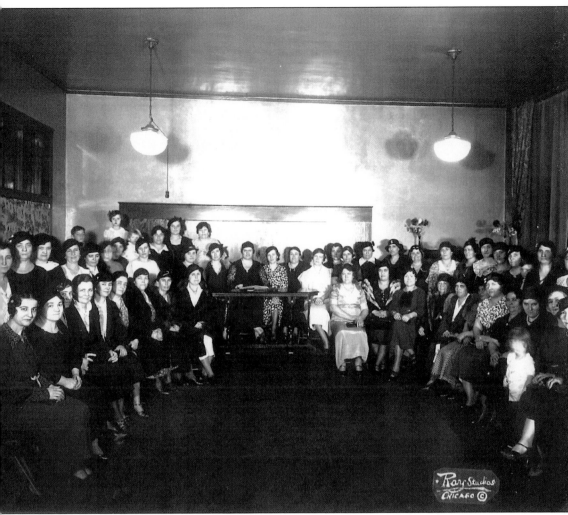

Presbytera Petrakis sits at the table, second from the left, at this meeting of the Koraes School Mothers' Club in the community room of SS. Constantine and Helen Greek Orthodox Church, 6105 S. Michigan, Chicago, c. 1936. Founded in 1929, the organization provided support and aid in the form of free textbooks, lunch programs, and tuition payments for indigent children. During the Great Depression of the 1930s, the assistance of the Mothers' Club was crucial in keeping these schools open. (Ray Studio photo.)

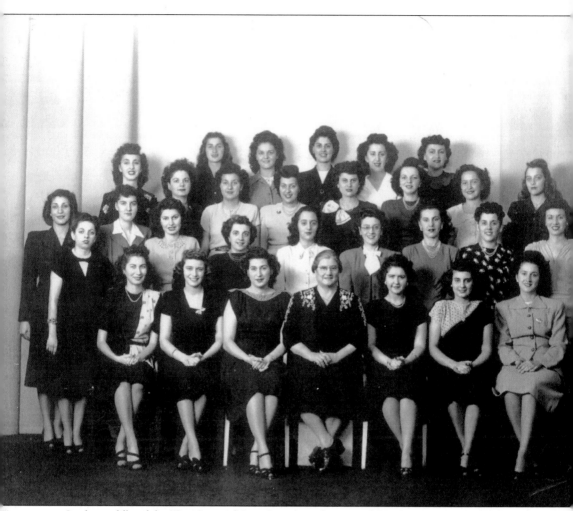

In the middle of the Nea Genea (New Generation) group of SS. Constantine and Helen Church Greek Orthodox Church sits Presbytera Petrakis, founder of the group, c. 1937. This group was founded in the 1920s for the young single women of the parish. Pictured seated in the front row, from left to right, are Georgia Lembares, Tessie Ann Callas, Bertha Kolins, Presbytera Stella Petrakis, Toula Erotas, Neovi Georgoulis, and Demetra Kopan. In the second row, from left to right, are Pat Kasson, Kikki Rentas, Edna Costopoulos, Helen Chrones, Edna Varvares, Doris Vaselopoulos, Pauline Gianakos, Ann Bratsos, Virginia Kopan, and Adeline Pappas. In the third row, from left to right, are Georgia Zervas, Helen Poulos, Penny Kolins, Fay Kolins, Marge Georgoulis, Fay Mezilson, Kathleen Javellas, and Dorothy Tripodis. In the back row, from left to right, are Minerva Tripodis, Estelle Komondouros, Helen Spiro, Evangeline Zervas, and Angeline Georgoulis.

Church Raises a Service Banner

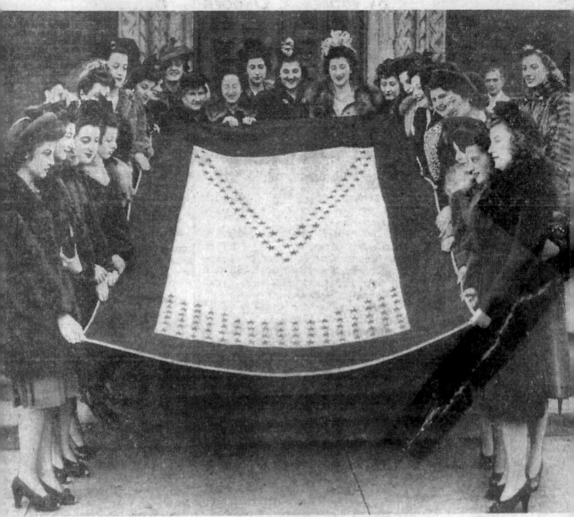

HEY SEWED THEIR OWN SERVICE FLAG, with stars denoting parish members in serv
nd then these members of the Young Ladies Hellenic Society, "Nea Genea," presented
 priest of St. Constantine's Greek Orthodox Church, 6105 S. Michigan av. Flag was rai

The young women of Nea Genea display a flag they sewed denoting parish members in service during World War II. The flag was raised at SS. Constantine and Helen Greek Orthodox Church, 6105 S. Michigan, Chicago. In the 1920s, 1930s, and 1940s, young Greek women generally did not date. As well as providing service to the community, Nea Genea served as a social outlet. According to member Fay Mezilson Machinis, "Presbytera was called the sponsor of our group and would be at all the meetings to give advice. She helped organize various activities, such as rolling bandages for the Red Cross, collecting money for the Greek War Relief outside of the McVickers' Theater, presenting Greek plays, organizing social dances (25¢ admission) at the church hall, having picnics, going on long hikes, playing softball, roller skating at the roller rink, and going to a special restaurant on Mother's Day to have dinner together. Every year at our first meeting of the year, we would celebrate by Presbytera baking a large vasilopita for everyone."

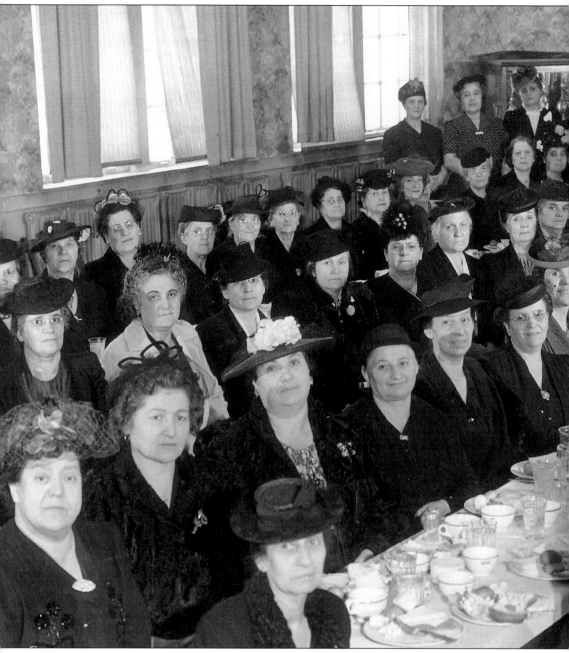

The Gold Star Mothers received many thank you cards and letters from grateful servicemen and servicewomen. Here are a couple of excerpts from the precious letters which Presbytera Petrakis saved, carefully tied in a bundle:

"Informing you in a few lines that I received your most welcome Christmas package. Sure has been a long time since I had *Loukoums* and once again I was hearty satisfied."

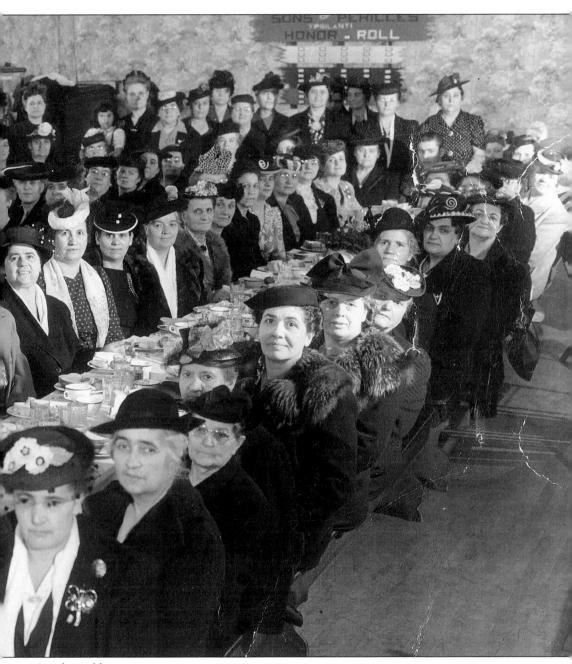

Another soldier writes,

"It was the best Christmas gift I received. If only I could explain to you what that little gift does to the morale of the Greek boys in the army. It isn't the gift so much as it is the idea that the Greek people back home are thinking of us."

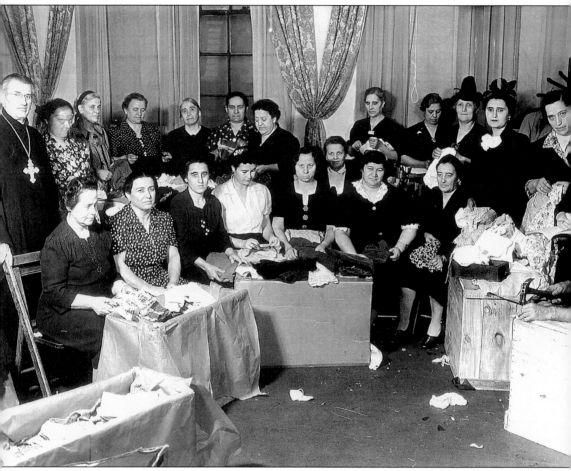

Women of SS. Constantine and Helen Greek Orthodox Church, 6105 S. Michigan, Chicago, pack clothes for shipment to Greece for the Greek War Relief effort in the 1940s during the Nazi occupation of Greece. Presbytera Petrakis is at the far right of the photo and her husband, Reverend Mark Petrakis, is on the far left. The church sexton, Spero Georgelas, is preparing the wooden boxes for shipment.

Most of the families who had settled in the United States had close relatives in Greece who were suffering from the upheaval of World War II. After the war, thousands of Greeks flocked to the U.S.A. to join their sisters and brothers, sons and daughters, aunts and uncles. (Andrew T. Kopan Collection.)

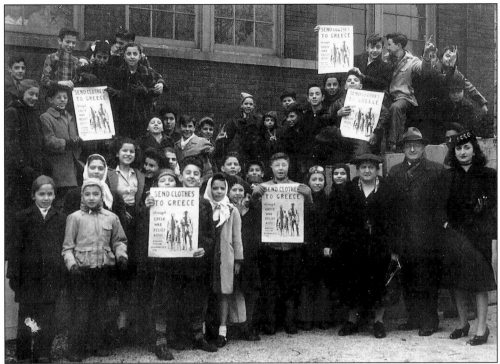

The students of Koraes School of SS. Constantine and Helen Greek Orthodox Church, 6105 S. Michigan, Chicago, participate in a rally and clothing drive for the Greek War Relief effort. Presbytera Petrakis is on the left of Dimitri Parry, attorney and Secretary of the Greek War Relief Association. Poppy Paleologos Mitchell, staff member, is on the right. (Andrew T. Kopan Collection.)

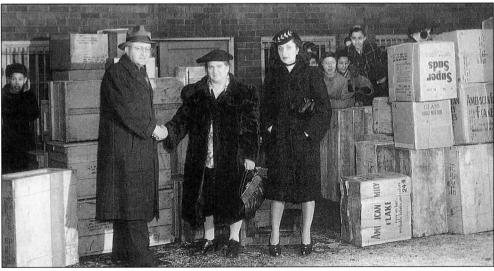

Attorney Dimitri Parry, Secretary of the Greek War Relief Association, congratulates Presbytera Petrakis for her assistance with the Greek War Relief effort at SS. Constantine and Helen Greek Orthodox Church, 6105 S. Michigan, Chicago. Poppy Paleologos Mitchell is on the right, with children from the Koraes School in the background. (Andrew T. Kopan Collection.)

PHONE: STATE 2274

GREEK WAR RELIEF ASSOCIATION, INC.

HARRY A. RECKAS, Regional Director for Mid-West States
Room 715 — 77 W. Washington Street
CHICAGO, ILL.

November 30, 1940

Presbytera Petrakis
6132 South Eberhart
Chicago, Illinois

Mr. dear Mrs. Petrakis:

You have been appointed as Chairman of the
Ladies' Auxiliary Committee for the purpose of helping
in the campaign to raise funds for the relief of
suffering Greeks in Greece. You are allowed by the
Executive Board to select the members on the Committee
and submit the names for approval to the Executive
Board.

Will you please appoint those members
immediately and communicate with the Secretary so that
a proper record may be made of their names and so that
the Committee may be organized to proceed to work.

Yours respectfully,

THE GREEK WAR RELIEF ASSOC., INC

John C. Gekas
Secretary

JCG:pm

Presbytera served as chairman of the Ladies' Auxiliary Committee for the Greek War Relief
Association, Inc. Her son-in-law, John L. Manta, was president of the Greek War Relief
Association, Inc., a nationwide organization. They raised money to send medical and food supplies
to Greece through the International Red Cross during the occupation of Greece in World War II.
Thousands of Greeks starved to death during those terrible years.

Ο λόγος που ...
ι'σδωσαν το Διάγωμα

At the time my husband and I came
to the United States in 1916, Miss
Jane Adams and her work among immigrants
was well known. When we moved to
Chicago in 1923 we met this great
lady and received her help many times
with the problems of our people.

Through the years her work has been
continued by the dedicated people of the
Immigrants Service League.

I am sure that many other men and women
deserve this award more than I do. But
I accept it gratefully and thank
you for your kindness.

This typed copy of Presbytera Petrakis' speech that she gave when she was honored by the
Immigrants' Service League shows the respect she and the Greek community had for Jane Addams,
founder of Hull House. For many years, Presbytera Petrakis worked along with Venette Askounes
to raise money for the Immigrants' Service League.

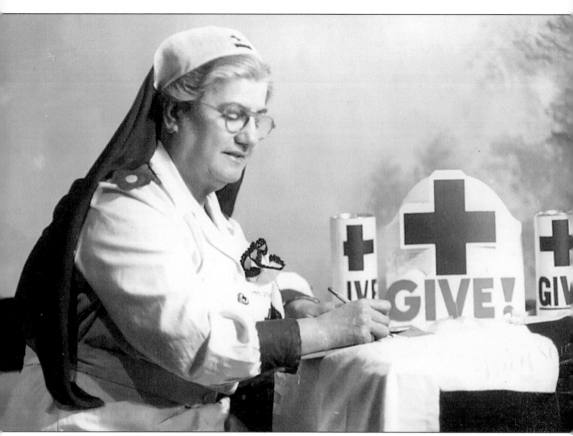

Presbytera Stella Petrakis volunteered for the Red Cross for over 60 years and organized units not only in Chicago but also in other parts of the country. Presbytera Petrakis received the Immigrants' Service League's Distinguished Achievement Award for her outstanding contribution as a Red Cross worker.

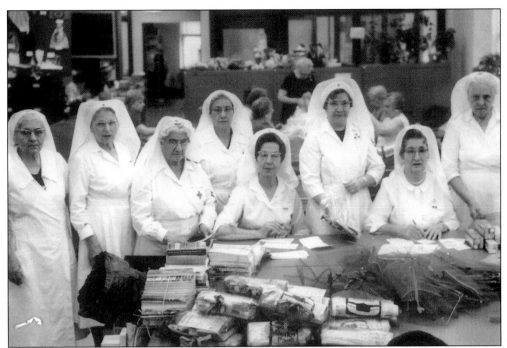

According to Dr. Andrew T. Kopan, whose mother attended the group, the Red Cross unit at SS. Constantine and Helen Greek Orthodox Church met on Tuesday afternoons at the church. While the Red Cross group worked at rolling bandages, Presbytera Petrakis would read to them from the Greek or American papers. (Andrew T. Kopan Collection.)

Reverend Byron Papanikolaou and Presbytera Petrakis (to his right) pose with the Red Cross group from SS. Constantine and Helen Greek Orthodox Church. (Andrew T. Kopan Collection.)

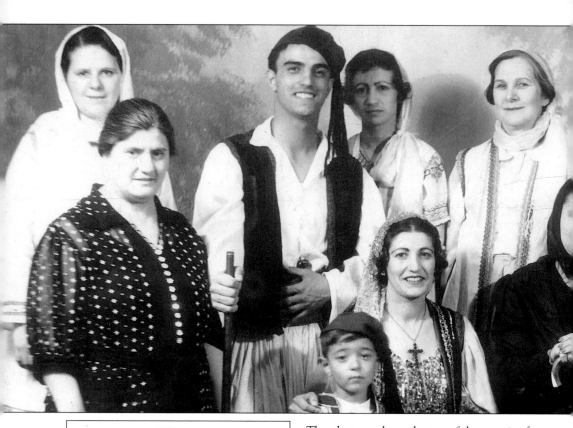

The photograph on the top of the page is of the actors and actresses in the play, including the author's son, Harry Mark Petrakis, who is standing in the back, third from the right. The play is about the women of Zalloggou who danced to their death over the side of a cliff rather than face enslavement by the Turks.

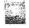
This playbill is from the play, *The Dance of Zalloggou*, that Presbytera Petrakis directed in Albuquerque, New Mexico in 1938 to raise funds for the new American Hellenic Educational Progressive Association (AHEPA) Sanitorium. Never one to sit and relax, when Presbytera Petrakis traveled there for her daughter's health, she got actively involved in organizing the community. According to her son, Harry Mark Petrakis, who accompanied her, she was involved in planning the building of a chapel and bringing in a priest.

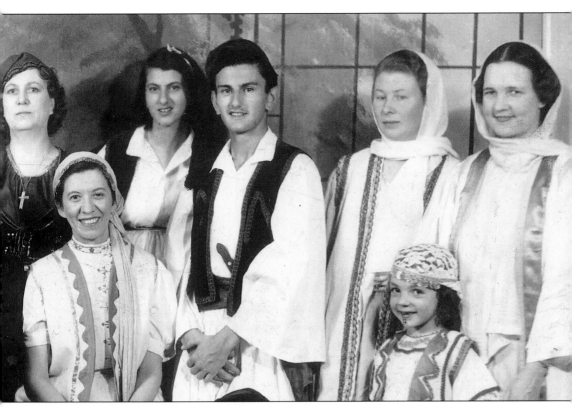

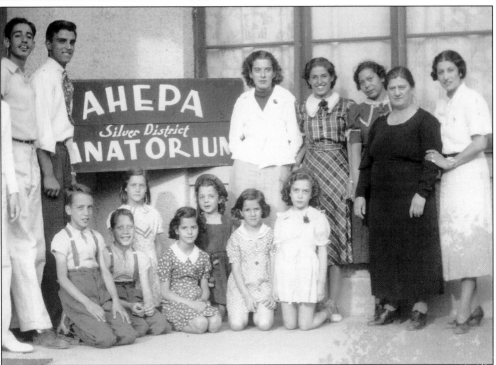

This group is in front of the AHEPA Sanitorium in Albuquerque, New Mexico.

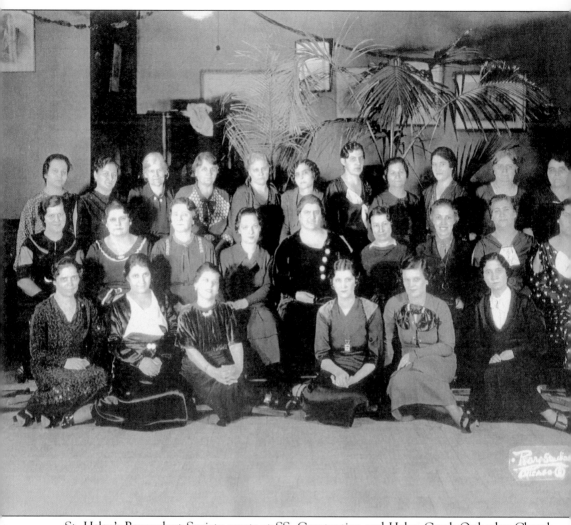

St. Helen's Benevolent Society meets at SS. Constantine and Helen Greek Orthodox Church, 6105 S. Michigan, Chicago. Presbytera Petrakis, founder of this organization, sits in the middle. (Ray Studio Photo.)

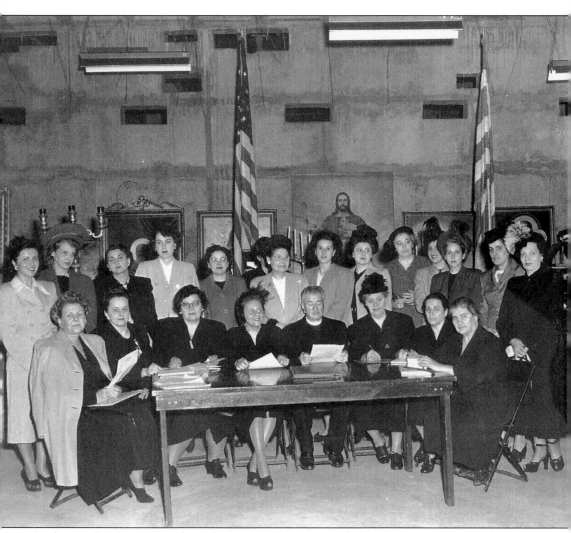

Presbytera Petrakis sits on the right in this 1946 photo of a fund-raising committee for SS. Constantine and Helen Greek Orthodox Church, 7351 S. Stony Island, Chicago.

Presbytera Stella Petrakis and Vicky Djikas prepare for a fund raiser at SS. Constantine and Helen Greek Orthodox Church. Presbytera Petrakis, along with the other women of the church, worked tirelessly in the kitchen for parish events.

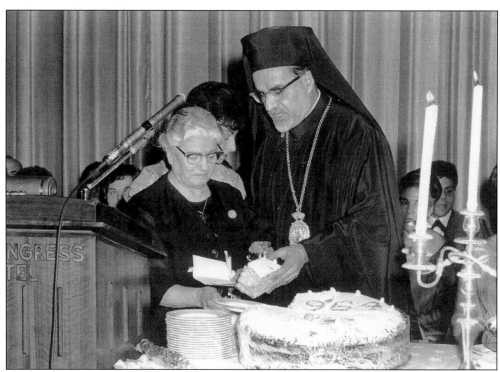

Bishop Meletios Tripodakis gives Presbytera Petrakis a piece of *vasilopita* (sweet holiday bread), c. 1964. She helped organize these annual citywide celebrations of St. Basil's Day.

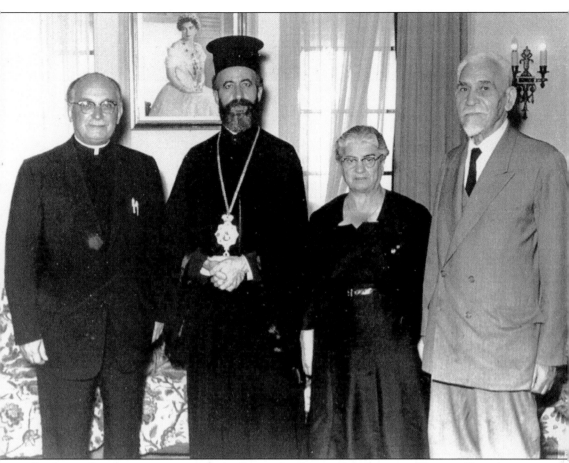

Presbytera Petrakis was active with the Justice for Cyprus Committee in Chicago. Here she is, c. 1966, with Rev. Nikitas Kesses to the left and Archbishop Makarios of Cyprus. The person on the right is unidentified.

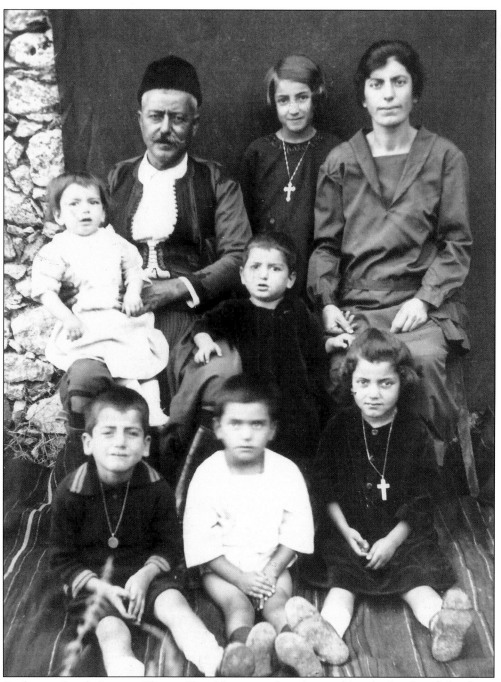

Presbytera Petrakis' sister, Efrosini Kotsifakis, sent this photo of her husband and family to Presbytera Petrakis from Greece. Presbytera and her two sisters exchanged letters on a regular basis during the many years of their separation. Tough conditions in Greece made it difficult, and sometimes impossible, for Greek-American immigrants to travel to Greece until the 1950s and 1960s. Greece, a poor country, suffered from the ravages of the Balkan Wars, World War I, the Great Depression, World War II, the Nazi occupation, and the Greek Civil War (which followed World War II).

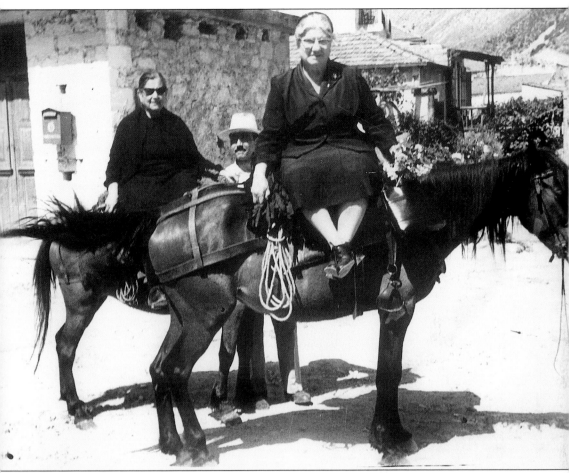

Presbytera Petrakis rides a donkey in her hometown of Nipos, Crete. She returned to Greece in 1952, after 36 years in America. She is with her cousin, Eleni Zerboudaki. Presbytera Petrakis was joyfully reunited with relatives and friends. Sadly, her two sisters had both died before Presbytera Petrakis returned to Greece.

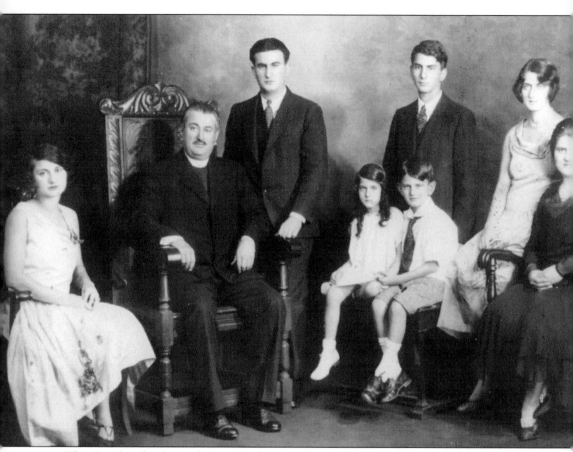

The Petrakis family is shown together in Chicago, c. 1934. Pictured, from left to right, are Tasula, Rev. Mark Petrakis, Dan, Irene and Harry (both seated), Manuel, Barbara, and Presbytera Petrakis.

Tasula, a University of Chicago honors graduate, married John Thoman, an artist she met at the 1933 Century of Progress World's Fair. They lived in Independence, Missouri and had four children, Mark, Barbara, Lea, and Nikki.

Dan, a graduate of Wake Forest, worked as a steel executive for U.S. Steel, Columbia Geneva Steel, and Esso Pappas in Greece. He married Penny Siavelis and they had one daughter, Barbara. Dan and Penny divorced. Later, Dan married Marvel Lystne and settled in California.

Irene, who studied mechanical engineering at Chicago Technical College, was a pilot for the civil air patrol during World War II. She was also employed in technical drawing and accounting. She and her husband, Ray Fox, resided in Oak Forest, Illinois. Their children are Keith and Karin.

Harry Mark Petrakis attended the University of Illinois. He married Diana Perparos and they have three sons: Mark, John, and Dean. Harry, a renowned author, has published 16 books and has become the recorder of the family's and the Greek community's history. He and Diana reside in Dune Acres, Indiana.

Manuel graduated from the University of Illinois where he studied entomology. He joined the army in 1941 where he remained for 20 years, achieving the rank of Lieutenant Colonel. He and his wife, Carmencita Diaz, are in San Francisco, California. They named their daughter Stella, after her grandmother.

Barbara graduated from Lake Forest College and married John Manta, an Icarian businessman. He achieved prominence in the Greek-American community as president of AHEPA and the Greek War Relief. They lived in Chicago where they raised their sons, Leo, Frank, and Steve.

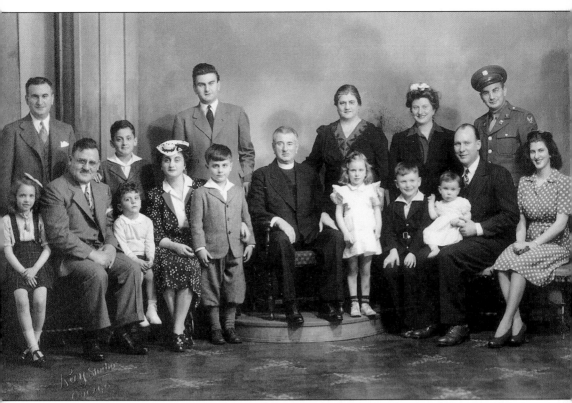

This photo, which was taken by Ray Studio, *c.* 1941, shows the family of Reverend Mark Petrakis and Presbytera Stella Petrakis. From left to right, in the bottom row, are Barbara Petrakis, John Manta, Steve Manta, Barbara Manta, Frank Manta, Father Mark Petrakis, Barbara Thoman, Mark Thoman, Leola Thoman, John Thoman, and Irene Petrakis. In the back, standing, are Dan Petrakis, Leo Manta, Harry Petrakis, Presbytera Stella Petrakis, Sue Thoman, and Manuel Petrakis.

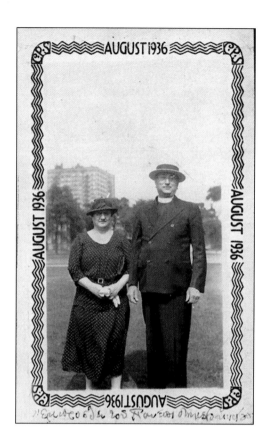

Presbytera Petrakis and her husband,
Rev. Mark E. Petrakis, enjoy an excursion in
August 1936.

Presbytera Petrakis takes pleasure in her
grandchildren, Leo Manta, Frank Manta, and
Steve Manta in the 1940s.

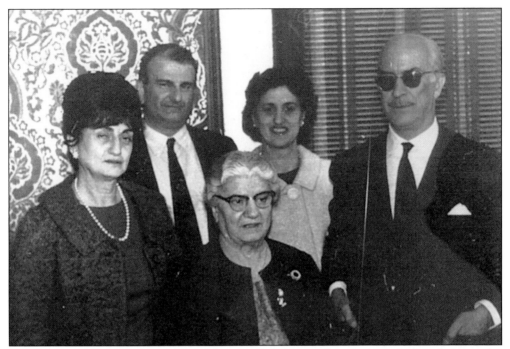

Presbytera Petrakis is in the middle of this photo. Others in this photograph, from left to right, are her daughter Barbara Manta, her son and daughter-in-law Harry Mark and Diana Petrakis, and Consul General Tsaousis of Greece.

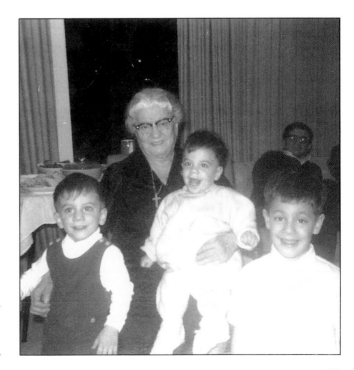

Presbytera Petrakis takes pride in her great-grandchildren, c. 1965. They are, from left to right, John Mark Manta, George Mark Manta, and John Leo Manta.

Elaine Cotsirilos Thomopoulos, Ph.D., is project director of GWUC's "Greek-American Women of Illinois Project", co-curator of the exhibit, "Greek-American Pioneer Women of Illinois," and editor of *Greek-American Pioneer Women of Illinois*.

Elaine Thomopoulos attended Elmhurst College and received her B.S. from Northwestern University, M.Ed. from the University of Illinois, and her Ph.D. in Clinical Psychology from the Illinois Institute of Technology. She has been assistant professor at Illinois Benedictine College, director of social services for the Hellenic Foundation, project director for Community Advocacy Network of Lutheran Social Services of Illinois (where she was senior editor of the book *Organizing a Volunteer Program Serving the Elderly*), co-founder and administrator of Greek-American Community Services, coordinator of the Chicago Ethnic Women's Coalition, and Chicago coordinator of the federally funded project "Innovative Approaches to the Dissemination of Caregiver Information Through Ethnic and Religious Groups."

Dr. Thomopoulos secured funding and coordinated the following arts and humanities programs: Greeks in America: Celebration on Film; Fabric Arts of Greece; Conference on Strains on Ethnic Pride: Conflict Between the New and the Old Immigrants in the Greek and Assyrian Communities; Greek Music and Dance; Greek-Americans in the Workplace; Cultural Enrichment for the Greek Elderly; Greek-American Poets and Musicians; Ethnic Identity and Leadership Development in Illinois; and Greek Dance.

Her voluntary activities include serving as past president of the GWUC and past president of the Annunciation Greek Orthodox Church of Benton Harbor, Michigan. She is now an officer of the Greek-American Nursing Home Committee and a member of the Community Partners of the Chicago Historical Society's project, "Out of the Loop: Neighborhood Voices."

Dr. Thomopoulos lectures and writes articles about the Greek-American community. She practices as a licensed clinical psychologist, and is also a broker associate with Coldwell Banker.

Elaine Cotsirilos Thomopoulos is married to Nick Thomopoulos, Ph.D. They live in Burr Ridge, Illinois and have four children: Marie (Mathieu Sussman), Melina, Diana, and Christopher, and two grandchildren: Lauren and Daniel. She is the daughter of Emily and the late George Cotsirilos.

Three

THEANO PAPAZOGLOU MARGARIS (1906–1991)

BY VIVIAN MARGARIS KALLEN

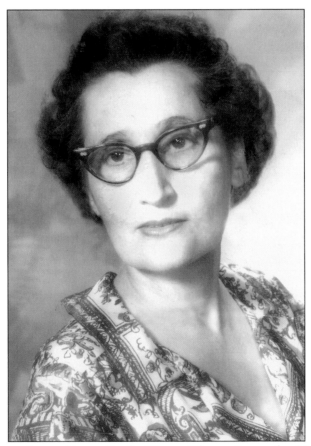

An award-winning author and journalist, for 50 years Theano Papazoglou Margaris chronicled, with feeling and grace and imagination, the lives of the Greeks of America and the Asia Minor Diaspora.

"Of all the Greek-language fiction writers in this country, none warrants our attention as much as Theano Papazoglou Margaris. . . Her work demonstrates analytical intellect, photographic realism, and a Chekhovian concern for the human condition. . . Margaris' work forms a portion of American literature, albeit in a language that prevents it from having other than a restricted readership." (Charles C. Moskos Jr., *Greek-Americans: Struggle for Success*, reprinted by permission of Transaction Publishers, p. 98.)

For over fifty years, Theano Papazoglou Margaris chronicled, with feeling and grace and imagination, the lives of the Greeks of America and of the Asia Minor Diaspora, but she steadfastly resisted pleas to write about her own life. Yet her life was an odyssey of heroic proportions—a story of courage, resilience, and determination in the face of tragedy and suffering and unimaginable obstacles. She resisted writing even a short autobiography because to recall directly would be too painful, but in her fiction she drew upon the events and experiences that shaped her character and intellect and which were, I believe, the wellspring of her remarkable creativity.

Traumatic events in her formative years permanently shaped her orientation to the world she lived in. She became an orphan at the age of eight; she was twice a refugee, at ages nine and sixteen; and she emigrated to America at age seventeen. She never got over her sense of loss, uprootedness, and disconnection with her past, or of the feeling that life is arbitrary and happiness illusory. But rather than give in to despair, she found inner reserves of strength and channeled her energy in directions that marked a clear determination to be in control of her own life. She became a feminist, she broke with religion, she became involved with labor and other left-leaning groups, and she became a crusader for the use of the demotic language in Greek letters.

For a woman born in a village in Asia Minor in 1906 and thrust into urban American life in the 1920s, she was a woman remarkably ahead of her times.

Theano was born on May 6, 1906, in Vatika, a Greek village in Turkey near the Sea of Marmara. For the time and place, her family was relatively well-off. Her mother, Theofane Nerantzis, was one of the very few women of the area who could read—not just Greek but, surprisingly, French, although her own mother, my great grandmother, was illiterate. Her father, George, had fairly extensive land holdings and was also the village priest. She was named Theodosia, and she was followed in the next eight years by three brothers—Theodore, John, and Gregory.

Her childhood was shattered on January 1, 1915, when her mother suddenly and tragically died. Her heartbroken father died four months later on St. George's Day, leaving the four children in care of their maternal grandparents, who took them to their island.

World War I was raging, and Turkey had sided with Germany. Fearing that the Greeks of the Marmara region would secretly aid the British, the Turkish government ordered a mass evacuation of the Greeks from the Dardanelles and along the Marmara coast. The horrors of that evacuation—hunger, disease, exhaustion, and death—haunted her and formed the backdrop of several of her short stories, most notably "Eftyhia" and "Easter in Balikesir" of her first book. Even as late as the 1991 Gulf War, nightly newsreels of bombing in Iraq could revive memories of that period, which she described in her newspaper columns at that time.

Just when she arrived with her grandparents in Istanbul—Constantinople—is not clear to me. She was definitely there by 1918, when her uncle Elias and aunt Diamando Nerantzis took care of her and her brothers for a brief time after their grandparents' death. Gregory and John were placed in orphanages. Theano was taken in as a companion to a girl her age, and her formal education continued in a catch-as-catch-can way including at the "residential school" on the island of Pringipos, now Buyuk Ada. Her love of reading was firmly established well before her parents' death. It was her escape and her comfort through the years of upheaval and all through her life.

For the Greeks of Asia Minor, 1922 was a year of unimaginable tragedy—the year of expulsion of thousands and thousands of Greeks from land that had been Greek for centuries before the Turks came. Euphemistically called the "exchange of populations," it was marked by terror, starvation, and violent death. Caught in the maelstrom, Theano ended up in Athens for a few months before she came to America.

Although by 1923 U.S. immigration laws had drastically cut back the number of southern and eastern European immigrants admitted to this country, Theodosia was able to come to America through the efforts of a maternal uncle, Theodosios Nerantzis, who lived in New York and who arranged to have a Greek-American World War I veteran, Constantine Leontopoulos, "adopt" her. She was 17, she knew absolutely no English but did know some French, and she was thrust into the confusion of life in New York. Her uncle immediately arranged a job for her at a Nabisco plant. She never wanted to talk about this period, but I have the feeling her uncle was a harsh taskmaster who took most of her paltry wages for himself.

It was during this period that she bitterly renounced religion, feeling that she could not believe in a God who allowed wars and hunger and injustice. Although she later made her peace with the church as an institution, she never recovered her religious faith.

Remarkably, she began to write. Her first piece, "Manna in my Dreams," was published by a left-wing Greek newspaper, *The Voice of the Worker*. She was 18. I have no copy of it, but she described it once as an essay on the social injustice of some living in dire straits while others had endless wealth. She was urged to write more; she was a real discovery for this struggling newspaper. She took the name Theano because she did not want her uncle to know she was writing. By the time she was twenty she was also involved in the labor movement, helping to organize a Greek furriers' local in about 1926, and writing articles exhorting them to fight for better wages and working conditions.

This was a period when amateur Greek theatrical groups were a common feature in cities with large immigrant populations. By 1924, Theano was drawn to the stage and moved quickly to "starring" roles with groups that played before various organizations in New York and New Jersey. Writing, acting, organizing: she was anything but a helpless waif.

She moved to California for a brief period and again found herself in Greek theatrical productions in San Francisco. She was also involved enough politically to march in protests in support of Sacco and Vanzetti. The title story of her second book, *A Tear for Barba Jimmy*, describing the efforts of Greek waiters to unionize, was based on that period. She supported herself primarily by working as a sewing machine operator in small factories, finding time at night to continue her writing.

By 1927, she had returned to New York where she met and married my father, John Malaxos, who was from the Greek island of Castellorizo in the Mediterranean Sea, two miles off the southeast coast of Turkey. I was born in March 1929, seven months before the stock market crash that was followed by the Depression. Malaxos was caught in the economic upheaval, dragging his small family by Greyhound from New York to San Francisco to Los Angeles to Chicago in search of employment. When he left Chicago, once again, in search of employment (the day before she was scheduled to give a lecture, "The Role of Women Through the Ages," at a Halsted Street meeting hall), Theano informed him that she was staying in Chicago. It was 1933. She had found her *patrida*, her homeland. She also filed for divorce. It could have been a step into the abyss, but Theano was a survivor.

We lived briefly in a large old apartment building on Chicago's near west side. Her writing and acting provided a quick entree into the Greek community centered around Halsted Street, and her proficiency on the sewing machine supplemented the help she got from the Relief, the Depression-era equivalent of welfare. Long after most Greeks had moved away, Halsted Street remained the center of Greek life. Restaurants like Spiropoulos and Macedonia were gathering places where one could hear serious, intense discussions on the *glossiko* (language) question or on Greece's literary figures, hear Greek music and enjoy familiar foods, and wait for Agia Triada's *epitafio* on Good Friday.

At Halsted and Harrison, Kentrikon, a store that carried Greek books, newspapers, records, and food, was a cultural oasis for the immigrants of the era, and Hull House nearby welcomed them, providing theatre and meeting space and easing their transition to life in America. Also on Halsted Street was *leske* (the club), the second-floor meeting place of the Prometheus Lodge of the IWO, the International Workers Order, where politics with a leftist slant was the binding element. I remember *leske* as a place where men who had given up the dream of marrying and having a family

could come for a Turkish coffee and a cellophane-wrapped sesame *pasteli* (candy) and enjoy the contact with the few families who had children. There were occasional lectures and theatrical productions, but mostly it was a place where you talked about politics. The newspaper of choice was *Embros*, and its later incarnation, *Vema*, which carried Theano's column.

The gods were smiling on us when Theano met Bobby Margaris, who came from the island of Zakinthos in the Ionian Sea. He was a machinist in the small Greek-owned National Paper Napkin Manufacturing Company, located on the near west side of Chicago and owned by Andreas Deliyannis and George Bourdis. Bobby admired her writing and was also involved in Greek theatrical productions—sometimes as translator, and often in the unglamorous role of prompter. My mother claimed that I picked him for her—and I believe that. He was a wonderful father. They married in late 1933 and until his death in 1972, he provided the stability and support that made it possible for her to devote herself to writing.

In the 1930s, Theano was honing her writing skills on a New York paper, *Embros* (Forward), and by 1939, at age 33, she was ready to publish her first book, *Eftyhia and Other Short Stories*. This was an incredibly bold venture. Women writers were still an oddity and Greek-American women writers . . . there were no others. Her work for left-leaning newspapers probably narrowed her potential audience, although without these papers she would never have had the opportunity to write and be published. Bobby willingly paid the publishing costs although his wages were very modest.

Most bold of all was her commitment to write totally in demotic Greek at a time when the conventional wisdom was that *katharevousa* (puristic or formal) should be the language of literature and *demotike* should be labeled *malliare*, a pejorative apparently derived from *hairy*. She also peppered her dialogue with Turkish-Greek words and usage which, predictably, offended some critics, although later generations of readers praised her style as original and evocative. Theano was now a crusader for *demotike*, arguing that it was rich and expressive and flexible precisely because it was the language of the people about and for whom she was writing. But the immigrants of that period did not buy books. *Eftyhia* did not sell (I have such love for this book that it still hurts to think of Theano throwing copies into the furnace), and it took almost twenty years before she tried again to publish another book.

At some period—I believe it was about 1939 or 1940—*Embros* had folded and she was writing for *Vema* (*Greek-American Tribune*). For six years she had her own weekly "women's page," and the creativity in these pages is truly remarkable. In addition to her column, she carried poetry by women and wrote short pieces on child care, cooking, and nutrition (again ahead of her time), and carried letters from her readers. The feminist message was already strong, whether through insisting on the need to educate daughters as well as sons, raising women's consciousness of their rights, attacking the institution of dowries, calling for the extension of full voting rights to women in Greece after World War II, or praising her heroines—especially Jane Addams, Eleanor Roosevelt, and Susan B. Anthony.

Columns at that time, and all through her writing career, also reflected her love of modern Greek literature. Although she never attempted to write poetry, she became a discerning critic and promoter of Greek poetry in her columns and in her lectures. After the war, she found herself showered with books from writers in Greece who appreciated her commitment to *demotike* and who admired her writing and her perceptive critiques. Her following among other Diaspora Greeks grew after the war, too, because prestigious literary magazines in London, Istanbul, Cyprus, and Athens were publishing her short stories. She had become the preeminent chronicler of the life of Greeks in America.

After the war, she also reestablished contact with her brothers Theodore and John, whose whereabouts had been unknown to her for almost eight years. She was inconsolable when she learned that the youngest, Gregory, had been killed in an accident in the late 1930s. John, who had received a good education through the Near East Foundation, had been taken prisoner of war by the Italians. Other Italians helped him escape to Switzerland, where he rode out the war in reasonably good circumstances. He was married and living in Salonika, but he never lived up to his potential.

Theodore, the eldest of the three boys, went to the University of Athens after the war, and had a very distinguished career in the Greek civil service. He authored four books on administrative law and he had an enviable family life. His wife, Iphigenia, and daughters, my beloved cousins Fani and Roula, both professionals, were the joy of his life, as were his three grandchildren. One of my mother's happiest memories was the week she spent with the family on Rhodes, where Theodore was second-in-command for the Dodecanese. He was only seven when their parents died, and he too was caught in the upheavals of the time. The resilience of the two older siblings, Theano and Theodore, is truly inspiring.

By 1958, she decided to approach publishers in Greece with her second book, A Tear for Barba Jimmy, a collection of twelve short stories set in America. By now her work had received critical acclaim, and the influx of well-educated Greeks after the war provided a broader audience. Nine years later her book of essays titled Penstrokes from Chicago was published under the auspices of Chicago's Greek Press and Greek Star, where most of the essays first appeared.

Chronicle of Halsted Street in 1963 was a turning point, because with it she won the Greek National Award in Literature, the first Diaspora Greek to be so honored. Chronicle has some of her most powerful and moving stories. She wrote of the struggles and the heartbreak, the aspirations and the disappointments of the Greeks of America with a mature confidence and a writing style uniquely hers and immediately identifiable as "Theano." In 1967, she was admitted to Greece's prestigious National Society of Greek Literary Writers.

By the 1970s, Theano was writing a weekly column for the leading Greek-American newspaper, the National Herald, which was published in New York. In 1972, the Herald sent her to Istanbul, where she wrote an evocative series of articles blending remembrances of the mythic Constantinople of her childhood with observations of the now de-Hellenized city.

In 1972, The Misadventures of Uncle Plato was published and quickly sold out, in part because the Archdiocese recommended it for the libraries of America's Greek schools. Uncle Plato received the Max Manus Prize for Greek Literature from the Center for Neo-Hellenic Studies of the University of Texas in Austin, Texas.

From the 1970s until her death in 1991, she was also writing for other Greek language publications, including Chicago newspapers, never running out of ideas and always eager to introduce her readers to writers, teachers, and organizations working for the preservation of Greek language and culture. She was also in demand as a lecturer. There is wisdom and humor and history in her works. Although she never returned to the faith of her fathers, she had by now developed strong ties with many leading church figures. She saw the church as protector and center of Greek language and culture. Archbishop Iakovos and Patriarch Athenagoras were among her admirers, and in 1969 she received a unique honor: she was named "Archondissa" of the Ecumenical Throne.

Many organizations here and abroad honored Theano in her lifetime although she genuinely preferred not to be "fussed over." When the Constantinople Society of New York honored her in 1988, she began: "I thank all of you who came to honor me, but to tell you the truth, I didn't write for honors or for money. I wrote because I happened to be born at a very difficult epoch for Hellenism, and I saw so much that I had to write about it. I felt I would die if I didn't write."

Theano was at her battered and beloved typewriter writing her column for the National Herald when she had her first heart attack in October 1991 at age 85. My husband and I flew from Washington to be with her. She seemed to rally but one week later she had her second attack. We were with her. She was adamant about refusing "heroic measures." "Tell them I'm ready to die," she said in Greek. "I'm not ready to have you die," I cried as I cradled her in my arms. She sat upright and said in a clear voice, "I won't die. I will live in my writing."

Those were her last words. She was not afraid of death. She was clearly at peace with what she had made of her life and confident of her contribution to Greek letters. Walter Mondale in his eulogy of Hubert Humphrey ended with words that I find appropriate for my mother: She taught us how to live, and in the end she taught us how to die.

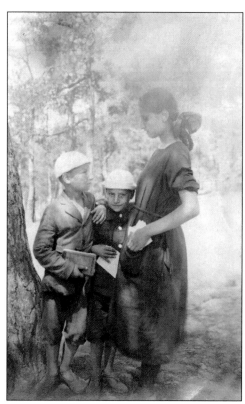

These two photos were taken in Asia Minor, c. 1922. Theano Papazoglou is about sixteen years of age and is with two of her three brothers: Gregory, about eight years old, and John, about nine. The other brother, Theodore, is not pictured. Shortly after these photos were taken, Papazoglou and her three brothers fled to Greece as refugees. All three of her brothers remained in Greece, while she immigrated to America six months after she had arrived in Greece.

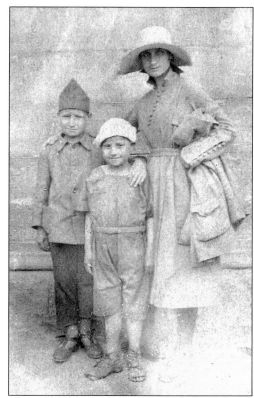

Theano Papazoglou poses with a companion in
Galata, Istanbul, Turkey, c. 1922.

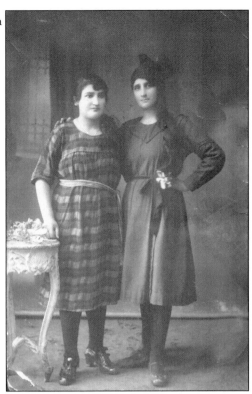

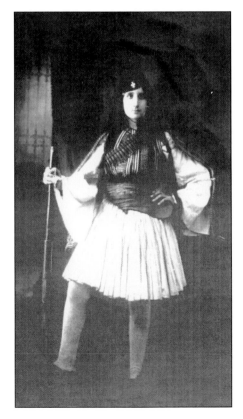

Theano Papazoglou is dressed as an *evzone*, an
infantryman belonging to an elite corps in the
Greek army. This photo was taken in Athens,
Greece in 1923.

With her stylish hat, Theano Papazoglou looks sophisticated in this passport photo even though she was only seventeen years old. As a refugee she fled from Asia Minor to Greece in 1922, spent about six months there, and then immigrated to America with this passport. She signed her passport Theodosia (her baptismal name) Leontopoulos because she came as the "adopted daughter" of Mr. Leontopoulos, who was a World War I veteran and American citizen. The subterfuge was necessary because by 1923 the National Origins Quota Act had effectively and drastically cut back immigration from southern and eastern Europe. Her uncle, Theodosios Nerantzis, who lived in New York, arranged the "adoption" so that she could be admitted into the United States. She had become Theano by 1924.

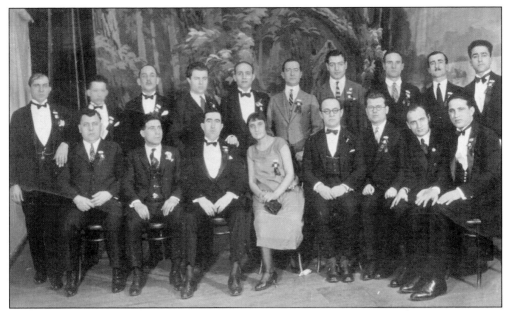

Theano Papazoglou is shown here with the Greek local of a furriers' union she helped to organize in New York, c. 1926. She was only about twenty years old when this photo was taken, seated in the front of these elegantly dressed, middle-aged men. She was also involved in labor activities in California and the Midwest.

Theano Papazoglou holds her daughter Vivian in 1929. Vivian, Theano's only child, is professor emerita at Northern Virginia Community College and lives in Arlington, Virginia with her husband, Arthur Kallen. They have two sons and three grandchildren.

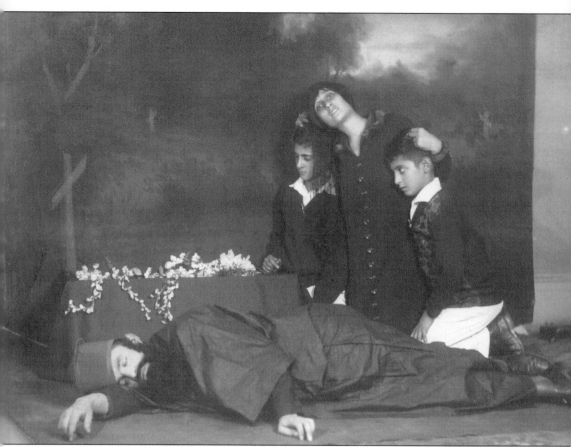

Greek theater played an important role in the life of the early Greek immigrants. Theano Papazoglou appears on stage c. 1927. She performed in numerous plays with Greek-American theater groups from 1923 through the 1940s. She also wrote one play. Her theater work frequently focused on social issues. She often said her acting experience was an important part of her education.

Theano performed in this play in 1924 at the Palm Garden in New York, just a year after she immigrated to New York. It was sponsored by the Pan-Messinians. The Greek-language play was part of a program that included dancing. Most of the dances were to American music; of 24 selections, only 3 were Greek dances.

69

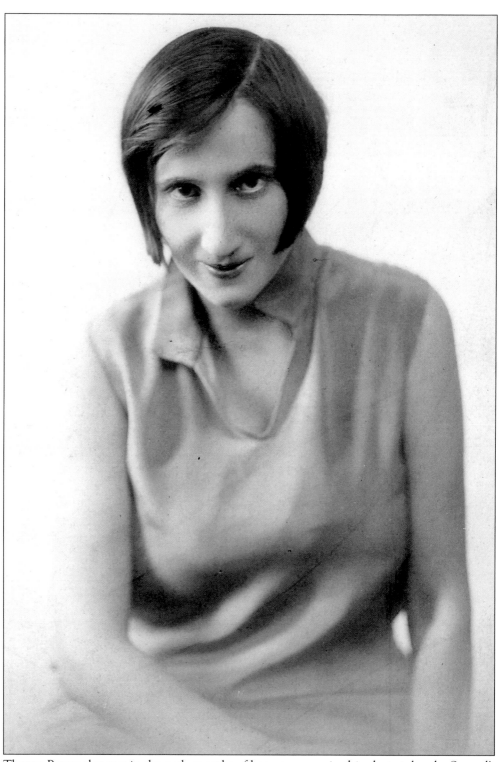

Theano Papazoglou was in the early months of her pregnancy in this photo taken by Samuel's Photo Studio in Astoria, New York in 1928.

∼ΠΡΟΓΡΑΜΜΑ∽

I

THE INTERNATIONAL ('Η Διεθνὴς) **E. POTIER**

Ὑπὸ τῆς Ὀρχήστρας διευθυνομένης ὑπὸ τοῦ Καθηγητοῦ κ.

Δ. Π. ΑΥΛΩΝΙΤΟΥ

II

ΤΟ ΑΡΙΣΤΟΥΡΓΗΜΑ ΤΟΥ ΣΠΥΡΟΥ ΜΕΛΑ

✠ ΤΟ ΑΣΠΡΟ ΚΑΙ ΤΟ ΜΑΥΡΟ ✠

Κοινωνικὸν Δρᾶμα σὲ Τρεῖς πράξεις

ΤΑ ΠΡΟΣΩΠΑ ΣΤΟ ΔΡΑΜΑ

ΚΩΣΤΑΣ, τμηματάρχης σὲ Τράπεζα - - -	ΣΩΚΡ. ΓΕΩΡΓΑΝΤΕΑΣ
ΑΛΚΗΣ, ἀδελφός του, γιατρὸς - - - -	ΔΗΜΟΣ ΒΛΑΧΟΣ
ΜΑΡΓΑΡΙΤΑ, μεγαλείτερή τους ἀδελφή - -	ΒΑΣΙΛΙΚΗ ΔΟΥΜΑ
ΑΝΘΗ, ἡ μικρότερη ἀδελφή - - - -	ΘΕΑΝΩ ΠΑΠΑΖΟΓΛΟΥ
ΠΕΡΣΕΦΟΝΗ, ἡ γριὰ μητέρα τους - - -	ΕΥΡΥΔ. ΚΟΖΑΝΙΔΟΥ
ΠΕΡΙΚΛΗΣ, ἀδερφός της, τοκιστής - - -	ΘΕΟΔ. ΠΑΠΠΑΣ
ΑΝΤΡΕΑΣ, ταγματάρχης τοῦ πυροβολικοῦ - -	ΑΛΕΚΟΣ ΧΑΤΖΗΣ
ΝΙΚΟΣ, λογιστής σὲ Τράπεζα - - - -	Ν. ΑΡΓΥΡΟΣ
ΦΩΤΕΙΝΗ, ἡ δούλα, - - - - - -	ΛΩΡΑ ΖΟΥΛΗ

ΠΕΡΙΛΗΨΙΣ ΤΟΥ ΕΡΓΟΥ

Ἡ ὑπόθεσις πλέκεται γύρω στοὺς σ.ἀπο.ους δεσμοὺς μὲ τοὺς ὁποίους συνδέ᾽ ονται τὰ μέλη τῆς σημερινῆς οἰκογένειας. Τὸ νεώτερο παιδί, ὁ Ἄλκης, στέλλεται στὸ Παρίσι νὰ σπουδάση γιατρός, παρὰ τὴ θέλησή του. Γι᾽ ὠγνώντας ἀρνεῖται νὰ κάμη τὸ γιατρὸ καὶ καυτηριάζει μὲ τσουχτερὴ γλώσσα τὰ ἄτοπα τῆς σημερινῆς οἰκογενείας.

Ἡ Μαργαρίτα, ἡ μεγαλείτερη ἀδελφή, ἔμεινε γεροντοκόρη, θυσιάσασα τὸν 15ετῆ ἔρωτά της χάριν τῶν ἄλλων μελῶν τῆς οἰκογενείας της. Ἡ νεωτέρα ἀδελφή της, ἡ Ἀνθή πέφτει θῦμα ἑνὸς πλουσίου νέου διαφθορέως, τὰς σχέσεις μὲ τὸν ὁποῖον ἡ μητέρα της τὰς εὐνοοῦσε γιατὶ ἤτανε πλουσιόπαιδο. Ὁ Κώστας, ὁ μεγαλείτερος ἀδερφός, ποὺ μόλις ὕστερα ἀπὸ πολλὰ βάσανα κατώρθωσε νὰ κάμη ἕνα μέλλον σὲ μιὰ Τράπεζα καὶ νὰ ἀρραβωνιασθῇ μὲ μιὰ κόρη «καλῆς» οἰκογενείας, κινδυνεύει νὰ χάση αὐτὰ ποὺ ἐπέτυχε, γιατὶ ὁ Ἄλκης ἄνοιξε χοροδιδασκαλεῖον, ἢ δὲ Ἀνθή ἀτιμάστικε. Οἱ συγγενεῖς τῆς μνηστῆς του τὸν ἀπειλοῦν πῶς θὰ χαλάσουν τὸ συνοικέσιο. Ὁ Κώστας δημοσιεύει στὶς ἐφημερίδες πῶς δὲν ἔχει καμμιὰ σχέσι μὲ τὸν Ἄλκη, βιάζει τὴν Ἀνθή ν᾽ αὐτοκτονήση γιὰ νὰ «πλύνη τὴν τιμὴ τῆς οἰκογενείας» καὶ νὰ πάρη τὴν προῖκα τῆς μνηστῆς του. Ὁ Ἄλκης ὅμως προφθάνει καὶ σώζει τὴν Ἀνθὴ καὶ τὴν πέρνει στὸ χοροδιδασκαλεῖο.

III

Violin Solo

α′	CZARDAS - - - - - - -	V. MONTI
β′	LA GITANA - - - - - -	FRITZ KREISLER
γ′	SERENADE - - - - - - -	E. TOSELLI

PROF. **DIOMED P. AVLONITIS**

VI

«ΘΑ ΣΕ ΓΕΛΑΣΩ»

Κωμῳδία σὲ μιὰ πράξη

ΥΠΟ ΤΟΥ ΘΙΑΣΟΥ ΤΟΥ κ. ΑΡΙΣΤ. ΠΑΡΙΣΗ

ΠΡΟΣΩΠΑ	ΗΘΟΠΟΙΟΙ
ΑΡΙΣΤΕΙΔΗΣ	ΓΙΑΝΝΗΣ ΘΥΜΙΟΣ

Theano performed in the play *The White and the Black* in 1924 in New York. The program also included classical music by Diomed P. Avlonitis and a comedy.

71

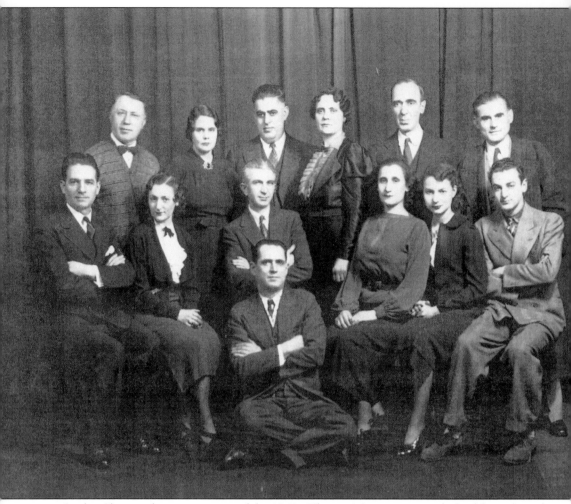

In this Chicago theater company of the 1940s, Theano Margaris is seated, third from the right. The company performed Greek plays in the Greek language as well as a few non-Greek plays, which were translated into Greek. Greek theater performances were held throughout the United States by theater companies and by church groups and organizations.

This 1926 play was given in Newark, New Jersey by the Greek Union of Hotel Employees at their first ball. The program says, "Dance until morning."

ΠΡΩΤΗ ΧΟΡΟΕΣΠΕΡΙΣ
ΤΗΣ ΛΕΣΧΗΣ ΕΛΛΗΝΩΝ ΕΡΓΑΤΩΝ ΞΕΝΟΔΟΧΕΙΩΝ
NEWARK, N. J.
ΕΙΣ ΤΟ JUNIOR ORDER HALL
ΠΑΡΑΣΚΕΥΗ, ΜΑΪΟΥ 7 1926

ΠΡΟΓΡΑΜΜΑ

I.

"Ο ΓΗΤΑΥΡΟΣ"
ΔΙΠΡΑΚΤΟ ΚΟΙΝΩΝΙΚΟ ΔΡΑΜΑ ΤΟΥ ΡΗΓΑ ΓΚΟΛΦΗ

Πρόσωπα: Ἐρασιτέχναι:

ΦΙΝΤΗΣ, ἐργοστασιάρχης Α. ΧΑΤΖΗΣ
ΣΤΑΥΡΟ, υἱός του Λ. ΧΑΪΔΟΥΣ
ΑΝΝΟΥΛΑ, κόρη του ΘΕΑΝΩ ΠΑΠΑΖΟΓΛΟΥ
ΓΙΑΓΙΑ (τῶν παιδιῶν καὶ πεθερὰ τοῦ Φιντῆ) Β. ΔΑΦΝΗ
ΜΗΧΑΝΙΚΟΣ Π. ΑΔΑΜΙΔΗΣ
ΥΠΗΡΕΤΗΣ

II.

ΕΡΓΑΤΙΚΗ ΜΑΝΔΟΛΙΝΑΤΑ
Ὑπὸ τὴν διεύθυνσιν τοῦ Μουσικοδιδασκάλου κ. Μ. Μιχαηλοπούλου

III.

"Η ΕΞ ΑΔΟΥ ΠΑΡΑΓΓΕΛΙΑ"
Μονόπρακτος Ξεκαρδιστικὴ Κωμωδία

Πρόσωπα: Ἐρασιτέχναι:

ΙΟΥΛΙΟΣ ΓΛΥΦΑΝΤΕΡΗΣ Ι. ΒΩΚΟΣ
ΜΕΛΠΟΜΕΝΗ, ἐρωμένη του Β. ΔΑΦΝΗ
ΦΥΚΑΡΗΣ, θεῖός του Λ. ΧΑΪΔΟΥΣ
ΣΥΜΒΟΛΑΙΟΓΡΑΦΟΣ Ν. ΑΔΑΜΙΔΗΣ
ΔΙΚΗΓΟΡΟΣ, φίλος τοῦ Γλυφαντέρη Κ. Δημητρακόπουλος

ΧΟΡΟΣ ΜΕΧΡΙ ΠΡΩΪΑΣ
Τῇ συνοδείᾳ Ὀρχήστρας, ὑπὸ τὴν διεύθυνσιν τοῦ κ. Ν. Καράμπελη

Τύποις «Ἠπείρου», 7 Oliver St., N. Y.

Greek Lodge No. 994
OF THE
International Workers Order
PRESENTS

"ΓΙΑ ΜΙΑ ΛΕΥΤΕΡΗ ΕΛΛΑΔΑ"
ΜΟΝΟΠΡΑΚΤΟΝ ΔΡΑΜΑ
(Ὑπὸ Θ. Παπαζόγλου)

ΚΥΡΙΑΚΗ ΜΑΡΤΙΟΥ 5, 1944
MILWAUKEE, WIS.

ΓΙΑ ΑΣΦΑΛΕΙΑ, ΠΡΟΣΤΑΣΙΑ, ΕΚΠΑΙΔΕΥΣΙ ΚΑΙ ΑΛΛΗΛΕΓΓΥΗ
Γίνετε Μέλη τῆς

INTERNATIONAL WORKERS ORDER
(ΔΙΕΘΝΟΥΣ ΕΡΓΑΤΙΚΗΣ ΑΔΕΛΦΟΤΗΤΟΣ)

Ἡ Ὀργάνωσίς μας παρέχει στὰ μέλη της ἀσφάλειαν ζωῆς, ἐπιδόματα ἀσθενείας, ἀναπηρίας καὶ φυματιώσεως μὲ πολὺ λαϊκὰ τιμάς.

ΠΑΡΑΔΕΙΓΜΑ:

Εἰς ἡλικίαν τριάντα (30) ἐτῶν, μὲ $1.37 τὸν μῆνα μπορεῖτε νὰ ἔχετε $1.0000.00 ἀσφάλεια ζωῆς.

Εἰς περίπτωσιν φυματιώσεως ἕως $600.00

Εἰς περίπτωσιν ἀνικανότητος ἕως $400.00

Εἰς περίπτωσιν ἀσθενείας $8.00 ἑβδομαδιαίως

Ὅλα τὰ ἀνωτέρω ὠφελήματα μόνο μὲ $1.37 τὸν μῆνα

Ἡ Ὀργάνωσίς μας λαμβάνει ἐνεργὸν μέρος εἰς τὸν σημερινὸν ὑπὲρ πάντων ἀγῶνα διὰ τὴν συντριβὴν τοῦ φασισμοῦ καὶ τὴν ἀπελευθέρωσιν τῶν ὑποδουλωμένων Λαῶν. ΕΙΝΕ ΔΙΚΗ ΣΑΣ ΟΡΓΑΝΩΣΙΣ. Ἀποτανθῆτε εἰς τὸ Ἑλληνικόν μας Τμῆμα:

526-A WEST WELLS STREET
Milwaukee 3, Wis.

Theano Margaris performed in the play *For a Free Greece* which was produced in 1944 by the International Workers Order, Greek Lodge No. 994 in Milwaukee, Wisconsin. On the playbill, it states "For insurance, education and mutual aid join the International Workers Order. Our organization provides its members life insurance, sickness benefits, disability and tuberculosis benefits at very popular prices."

73

ΘΕΑΤΡΙΚΗ ΠΑΡΑΣΤΑΣΙΣ ΤΟΥ ΣΥΛΛΟΓΟΥ
"ΚΩΝΣΤΑΝΤΙΝΟΥΠΟΛΙΣ"
ΥΠΕΡ ΤΟΥ ΓΚΡΗΚ ΓΟΥΩΡ ΡΕΛΗΦ

Μέρος Ι 'Ο 'Εθνικὸς Ὕμνος. Πιάνο.

Μέρος ΙΙ Τὸ τρίπρακτο δρᾶμα τοῦ 'Αμερικανοῦ συγγραφέως Ρ. Κινκὴντ

"Η ΠΑΡΑΣΤΡΑΤΗΜΕΝΗ"
Διανομὴ τοῦ ἔργου

ΠΡΟΣΩΠΑ	ΗΘΟΠΟΙΟΙ
Τζὼν Φούλερτον	Κ. ΟΙΚΟΝΟΜΟΥ
Κυρία Φούλερτον	Ρ. ΚΟΚΟΣΗ
Χέρρυ Φούλερτον (γυιός των)	Γ. ΜΑΣΤΡΟΠΟΥΛΟΣ
῎Αννα Φούλερτον (κόρη των)	Α. ΚΗΠΟΥΡΟΥ
'Εδουάρδος (ὑπηρέτης των)	Ν. ΤΣΙΦΙΤΟΠΟΥΛΟΣ
'Αλέκος Κόκλη (φίλος τοῦ Χέρρυ)	Ν. ΜΑΡΓΑΡΙΤΗΣ
Σὰμ Φίλσον (πρώην δικαστὴς)	Μ. ΜΑΡΓΑΡΗΣ
'Αηλὴν Νίλσον	Θ. ΠΑΠΑΖΟΓΛΟΥ—ΜΑΡΓΑΡΗ
Κυρία Νίλσον	Κ. ΜΟΥΖΑΚΙΩΤΗ
Γιάντης	Δ. ΜΠΙΡΜΠΙΛΗΣ
Στενογράφος	Ε. ΛΙΝΑΚΗ
Δικαστὴς	Θ. ΠΑΠΑΓΕΩΡΓΙΟΥ
Γραμματεὺς	Ν. ΚΥΡΙΑΖΗΣ

'Η πρώτη σκηνὴ στὸ σπίτι τοῦ Φούλερτον. 'Η δευτέρα στὸ δικηγορικὸ γραφεῖο τοῦ Σὰμ Φίλσον μετὰ ἕνα χρόνο. 'Η τρίτη στὸ δικαστήριον. 'Εποχὴ σύγχρονος.

Μέρος ΙΙΙ Λόγος ὑπὸ τῆς Προέδρου τοῦ Συλλόγου κ. Κ. Τσιφιτοπούλου

Μέρος ΙΙΙΙ Μονόπρακτος κωμῳδία τοῦ Ν. Λάσκαρη

Wayward Woman was performed for the Constantinople Society in Chicago, c. 1944, to raise funds for the Greek War Relief. Both Theano and her husband Bobby acted in this drama.

74

ΤΟ ΣΥΧΡΟΝΟ

"ΣΤΗΝ

ΕΡΓΟΝ ΠΟΥ
ΚΑΙ ΘΑ Σ

ΜΕΡΟΣ

Η ΞΕΚΑΡΔ

"ΑΚΟΜΗ ΔΕ

ΜΙΣΗ ΩΡ
ΑΠ

ΜΕΡΟΣ

Ἡ Πρωταγωνίστρια Θεόνη Μάργαρη

GREEK VA

ΟΛΟΙ ΟΙ ΚΟΡΥΦΑΙΟΙ ΕΛΛΗΝΕΣ ΚΑΛΛΙΤΕΧΝΑΙ ΤΟΥ
ΣΑΣ ΣΑΓΙΝΕΥΣΟΥΝ ΜΕ ΤΑ ΝΕΑ ΤΡΑ

ΜΟΥΣΙΚΗ ΥΠΟ ΤΟΥ ΓΝΩΤΟΥ Β

ΜΙΑΝ ΜΟΝΟΝ ΗΜΕΡΑΝ: ΚΥΡΙΑΚΗΝ 9ην

CHICAGO WOMAN'S CL

ΕΙΣΟΔΟΣ 50c ΚΑΙ 75c Plus Ta

Theano performed in *The Outer Door* at the Chicago Woman's Club in the 1930s.

ΚΑΛΛΙΤΕΧΝΙΚΗ ΕΣΠΕΡΙΣ

ΠΡΟΣ ΤΙΜΗΝ
ΤΩΝ ΑΝΤΙΠΡΟΣΩΠΩΝ
ΤΟΥ 4ου ΣΥΝΕΔΡΙΟΥ

ΤΗΣ ΕΛΛΗΝΙΚΗΣ

ΕΡΓΑΤΙΚ. ΕΚΠΑΙΔΕΥΤΙΚΗΣ ΟΜΟΣΠΟΝΔΙΑΣ ΑΜΕΡΙΚΗΣ

Ὑπὸ τὴν Αἰγῖδα

ΤΟΥ ΣΥΝΔΕΣΜΟΥ "ΠΡΟΜΗΘΕΥΣ"

Ἡ Καλλιτέχνις

ΘΕΑΝΩ ΜΑΡΓΑΡΗ
(ΠΑΠΑΖΟΓΛΟΥ)

Θὰ πρωταγωνιστήση

εἰς τὸ Κοινωνικὸν

Δρᾶμα

Η

"ΠΑΡΑΣΤΡΑΤΗΜΕΝΗ"

ΚΥΡΙΑΚΗΝ 6ην ΜΑΡΤΙΟΥ

Καὶ ὥραν 6ην μ. μ. ἀκριβῶς
Εἰς τὸ πολυτελὲς

Amalgamated Auditorium

This playbill is from the 1940s play *The Wayward Woman*. Theano starred as the wayward woman in this play for Prometheus, a Greek branch of the International Workers Order in Chicago. By 1941, it was called the Hellenic American Fraternal Society.

After being married to her first husband in 1927 and divorcing in 1933, Theano Margaris married Bobby Margaris, who is shown with her in this photo. Her daughter Vivian reports he was a wonderful father and husband and was very supportive of his wife's work. He helped her in every way he could, including paying for her first book, published in 1939. He also translated two of the plays in which she performed from English to Greek. When he died in 1971, they had been married for 37 years.

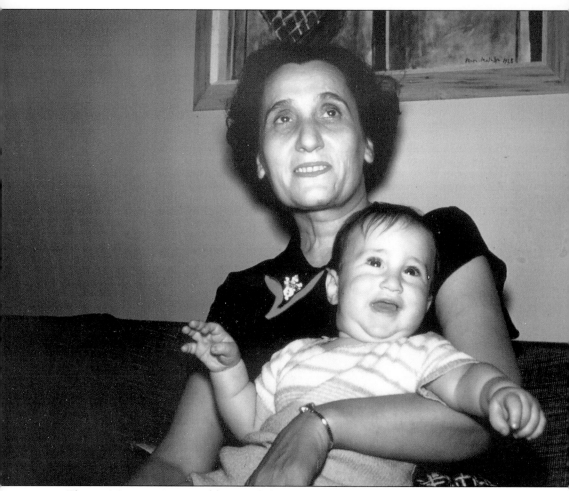

Theano Margaris is pictured here with her grandson, Jeffrey Leo Kallen, *c.* 1955. She had one daughter, Vivian Kallen, and two grandsons, Jeffrey Leo and Gregory Margaris Kallen.

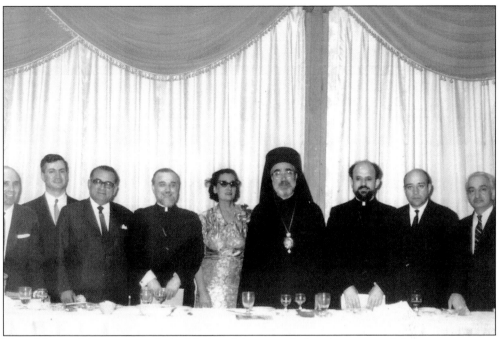

Here, Theano Margaris is with Archbishop Iakovos and church priests and dignitaries.

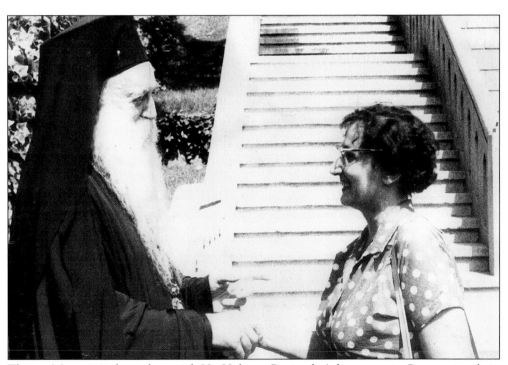

Theano Margaris is shown here with His Holiness Patriarch Athenagoras in Constantinople in 1962. Ten years later, in 1972, *The National Herald* sent her there to write a series of articles on the city of her childhood years.

Τῇ Εὐγενεστάτῃ κυρίᾳ Θεανοῖ Μάργαρη, θυγατρὶ ἡμῶν κατά πνεῦμα ἀγαπητῇ, χάριν καὶ εἰρήνην παρά Θεοῦ.

Τάς εὐσεβείᾳ καὶ ἀρετῇ κεκοσμημένας καὶ πολυτρόπως χρησίμους καὶ εὐεργετικάς ἑαυτάς τῇ Ὀρθοδόξῳ ἡμῶν Ἁγίᾳ τοῦ Χριστοῦ Ἐκκλησίᾳ καὶ τῷ εὐσεβεῖ Γένει καταδεικνύσας Χριστιανάς γυναῖκας, τιμᾶν οἶδε, ἡ Μήτηρ Ἐκκλησία διά τῆς ἀπονομῆς αὐταῖς τιμητικοῦ τίτλου καὶ διακρίσεως.

Ἐπειδή τοίνυν ἡ ὑμετέρα ἀγαπητή Εὐγένεια ἀναδέδεικται κεκοσμημένη τοιούτοις προτερήμασι, τοῦ ἑαυτῆς οἴκου καλῶς προϊσταμένη, παράδειγμά τε ζηλωτῆς φιλοτιμίας καὶ πρός τήν Ἐκκλησίαν ἀφοσιώσεως, ἡ Μετριότης ἡμῶν, ἐπιβραβεῦσαι βουλομένη τήν τοιαύτην αὐτῆς πορείαν καὶ προσήλωσιν, κατ' ἰδίαν Αὐτῆς Πατριαρχικήν φιλοτιμίαν καὶ προαίρεσιν, ἔγνω ἀπονεῖμαι αὐτῇ τόν τίτλον τῆς "Ἀρχοντίσσης τοῦ Οἰκουμενικοῦ Θρόνου".

Ἐφ' ᾧ καὶ γράφοντες ἀποφαινόμεθα, ὅπως ἀπό τοῦ νῦν ἡ ὑμετέρα Εὐγένεια ὑπάρχῃ καὶ λέγηται "Ἀρχόντισσα τοῦ Οἰκουμενικοῦ Θρόνου", πάσης τῆς προσηκούσης τῷ τίτλῳ τούτῳ τιμῆς πάντοτε καὶ παρά πάντων ἀπολαύουσα καὶ ἀξιουμένη.

Ὅθεν καὶ εἰς ἔνδειξιν ἀπελύσαμεν καὶ τό παρόν ἡμέτερον Πατριαρχικόν Εὐεργετήριον Γράμμα τῇ Εὐγενεστάτῃ Ἀρχοντίσσῃ τοῦ Οἰκουμενικοῦ Θρόνου κυρίᾳ Θεανοῖ Μάργαρη, ἐπικαλούμενοι ἐπ' αὐτήν καὶ τόν οἶκον αὐτῆς τήν εὐλογίαν τοῦ Ὑψίστου, σύν τῇ παρ' ἡμῶν εὐχῇ.

͵αϡξθ' Φεβρουαρίου ιδ'.

His Holiness Patriarch Athenagoras of Constantinople sent this letter to Theano Margaris conferring upon her the title of Archondissa of the Ecumenical Throne. This is the highest ecclesiastical honor bestowed on a lay person and one rarely given to a woman.

ΕΝΕΙΑΚΑ ΝΕΑ

Ι ΚΩΝΣΤΑΝΤΙΝΟΥΠΟΛΙΤΕΣ ΤΗΣ Ν.Υ. ΤΙΜΗΣΑΝ ΤΗ ΘΕΑΝΩ ΜΑΡΓΑΡΗ

Ή Θεανώ Μάργαρη στό βήμα

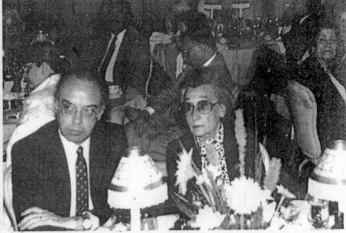

Ὁ γενικός πρόξενος τῆς Ἑλλάδας στή Ν.Υ. Γιώργος Ἀσημακόπουλος μέ τή Θεανώ Μάργαρη, κατά τή διάρκεια τῆς ἐκδήλωσης

Δέν ἔγραψα οὔτε γιά τιμές οὔτε γιά χρῆμα...

ὐχαριστῶ ὅλους σας, ό τήν καρδιά μου, ύ ἤρθατε νά μέ τιμή- τε, ἀλλά γιά νά σᾶς τήν ἀλήθεια, ἐγώ ν ἔγραψα οὔτε γιά ές οὔτε γιά χρῆμα. γραψα γιατί ἔτυχε νά ννηθῶ σέ πολύ δύ- ολη ἐποχή τοῦ Ἑλ- νισμοῦ καί εἶδα τόσα λλά πού ἔπρεπε νά

καί νά ξενιτευτεῖς τόσο μακρια, κραυγή, ἰδέα, λόγος, εἶπε ἡ ἐκπρό- σωπος τῆς Ἑταιρείας Ἑλλήνων Λο- γοτεχνῶν Ἀμερικῆς Ἑλένη - Φλω- ράτου Παΐδούση. Καί συνέχισε: «Ἡ ζωή σου ἐπίμοχθη γεμάτη

The Hellenic Society of Constantinople honored Theano Margaris in 1988 at the Plaza Hotel in New York. As reported in the *National Herald*, her words at this ceremony capture the essence of her work: "I thank all of you from the bottom of my heart for coming to honor me, but to tell you the truth, I didn't write for honors or for money. I wrote because I happened to be born at a very difficult epoch for Greeks and Hellenism. I felt that I would die if I didn't write. I saw so much: twice a refugee, uprootedness, then economic crisis." (Courtesy of the *National Herald*).

81

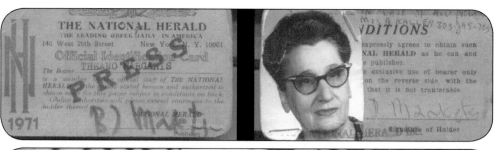

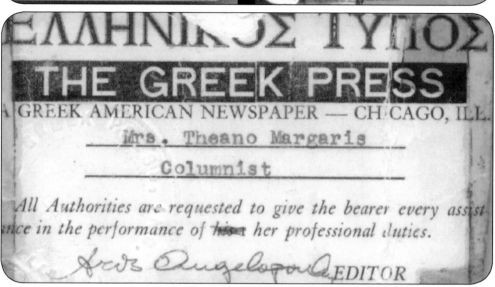

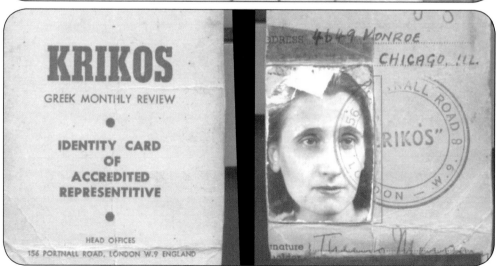

TOP: This is Theano Margaris' press pass for *The National Herald* in New York. Theano was a weekly columnist for *The National Herald* for 22 years.

MIDDLE: Theano also worked for the *Greek Press* and *Greek Star* newspapers of Chicago. This press pass is from the *Greek Press*.

BOTTOM: This press pass is for *Krikos* in London. Theano's stories were published internationally, including in Chicago, New York, London, and Athens.

ΕΘΝΙΚΗ ΕΤΑΙΡΙΑ ΤΩΝ ΕΛΛΗΝΩΝ ΛΟΓΟΤΕΧΝΩΝ

ΣΤΕΓΗ ΓΡΑΜΜΑΤΩΝ ΚΑΙ ΤΕΧΝΩΝ · ΜΗΤΡΟΠΟΛΕΩΣ 38 Τ. Τ. 126 · ΤΗΛΕΦ. 238.511

ΑΡΙΘ. ΠΡΩΤ. 635 ΑΘΗΝΑ 11 'Απριλίου 1967

 Πρός
 τήν κ. Θεανώ Μάργαρη
 4649 WEST MOUROE CHICAGO ILL
 U/S.A.

'Αγαπητή συνάδελφος,

 Εὐχαρίστως σᾶς ἀνακοινοῦμε ὅτι κατόπιν προτ΄σεως τοῦ
Διοικητικοῦ Συμβουλίου τῆς 'Εθνικῆς Εταιρίας τῶν .Ελλήνων Λογοτεχ-
νῶν ἡ Γενική Συνέλευση τῆς 6ης 'Απριλίου 1967 ἐπεκύ᷍ωσε σύμφωνα μέ
τό Καταστατικό μᾶς, τήν ἐκλογή σας ὡς τακτικοῦ μέλους τῆς 'Εταιρίας.

 Μέ τήν εὐκαιρία αὐτή σᾶς γνωρίζουμε ὅτι οἱ οἰκονομικές σας
ὑποχρεώσεις ποός τήν 'Εταιρία εἶναι:
Γιά ἐγγραφή δρχ. 100 καί γιά συνδρομή τοῦ 1967 δρχ. 50.

('Εκ τῆς Γραμματείας τῆς 'Εθνικῆς ,Εταιρίας τῶν 'Ελλήνων Λογοτεχνῶν)

This letter informs Theano Margaris of her acceptance into the prestigious National Society of Greek Literary Writers in 1967. During her lifetime, Theano published five books of short stories, two literary studies, one play, and countless articles. In 1963, she won the Greek National Literary Award for her book, *Chronicle of Halsted Street*.

This is a copy of the cover of *Eftyhia and Other Stories* (Chicago: Contemporary Thought, 1939).

This first work by Margaris included vignettes about the Greeks of Asia Minor, including their experience during the Diaspora of World War I and 1922 and their immigration to America. Margaris was disappointed that few in the Greek-American community bought this book. Heartbroken, she and her husband burned the extra copies, since there was no place to store them. She did not publish another book until nearly 20 years later.

This one-act play, *For a Free Greece* (New York: *Greek-American Tribune*, 1943) was produced to raise money for the Greek War Relief and portrayed the struggle of the Greeks under Nazi occupation.

Here, Theano Papazoglou enjoys an excursion near San Francisco in 1927. For a short time she lived in San Francisco, where she became interested in the plight of the Greek waiters. She wrote a short story describing the efforts of waiters trying to unionize in her book, *A Tear for Barba Jimmy*.

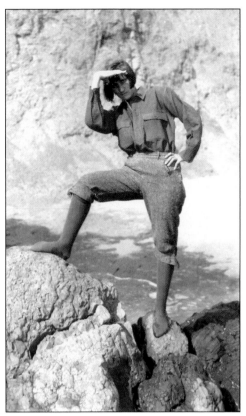

ΘΕΑΝΩ ΠΑΠΑΖΟΓΛΟΥ - ΜΑΡΓΑΡΗ

ΕΝΑ ΔΑΚΡΥ
ΓΙΑ ΤΟΝ
ΜΠΑΡΜΠΑ-ΤΖΙΜΗ

ΔΩΔΕΚΑ ΕΛΛΗΝΟΑΜΕΡΙΚΑΝΙΚΑ
ΔΙΗΓΗΜΑΤΑ

ΔΙΦΡΟΣ ◆ 1958 ◆ ΑΘΗΝΑ

This is a reproduction of the cover of *A Tear for Barba Jimmy* (Athens: Difros, 1958). The fates of various Greek immigrants are explored in this second volume of short stories by Margaris. The title story, which describes the struggle of Greek writers to unionize in San Francisco in the 1920s, was selected by Greece's Department of Education for its fifth grade reader. The remaining eleven stories are drawn from the Chicago Greek community.

Here is a reproduction of the cover of *Chronicle of Halsted Street* (Athens: Fexis, 1962; Second Edition, New York: *National Herald*, 1988). This collection of 16 short stories, Margaris' most well-known and popular work, cemented Margaris' fame by winning her the 1963 Greek National Literary Award. Margaris was the first author outside of Greece to receive this award. Many of the stories in this book focus on the emotional anguish of the immigrant caught between two worlds and are drawn from the lives of Greek-Americans in Chicago.

The Misadventures of Uncle Plato (Athens: Astir, 1972) was the winner of the Max Manus Prize for Greek Literature, Center for Neo-Hellenic Studies, in Austin, Texas. *Uncle Plato* uses Asia Minor, Chicago, and New York as settings for ten short stories.

ΘΕΑΝΩ ΠΑΠΑΖΟΓΛΟΥ ΜΑΡΓΑΡΗ

Γιώργης Κουτουμάνος

Ὁ ἀπόδημος τραγουδιστὴς καὶ φιλόσοφος

Δ Ι Α Λ Ε Ξ Η

ΣΥΛΛΟΓΟΣ ΑΠΟΦΟΙΤΩΝ
ΕΛΛΗΝΙΚΩΝ ΠΑΝΕΠΙΣΤΗΜΙΩΝ
ΝΕΑ ΥΟΡΚΗ 1968

In her 1968 lecture, *George Coutoumanos: The Expatriate Troubadour and Philosopher* (New York: Hellenic Universities Graduates' Association, New York, 1968), given to and published by the Hellenic Universities Graduates' Association, Theano discusses the life and poetry of George Coutoumanos, who was born in Messinia in 1876, emigrated to the United States in 1903, and died in Saugatuck, Michigan in 1962. He expressed in demotic poetry the same themes she explored in prose, particularly the pain of separation from the land of one's youth and a concern for social justice. Margaris was a discerning critic and worked to bring the work of other Greek writers to the attention of the reading public.

ΘΕΑΝΩ ΠΑΠΑΖΟΓΛΟΥ-ΜΑΡΓΑΡΗ

Η
ΠΟΙΗΣΗ
ΤΗΣ
ΔΙΑΛΕΧΤΗΣ
ΖΕΥΓΩΛΗ-ΓΛΕΖΟΥ

Ἐπιμέλεια:
ΦΩΤΙΟΣ Κ. ΛΙΤΣΑΣ

ΣΙΚΑΓΟ, 1986

The Poetry of Dialehti Zevgoli Glezou (Chicago: Modern Greek Studies Series, University of Illinois at Chicago, 1986 [Reprinted by permission of the Modern Greek Studies Program, Department of Classics, University of Illinois at Chicago]) is a transcript of a lecture and poetry reading given by Margaris in 1985 in Glenview, Illinois, with a prologue by Dr. Fotios Litsas and translations by Charles Stewart of Oxford University.

The photo is of Dialehti Zevgoli Glezou. Theano was drawn to Zevgoli's work for the way it expressed the yearning and sorrow that Greeks in Greece felt at the loss of their sons, brothers, and loved ones to America, many never to return. She states:

"I discerned in her poetry the unrelenting pain, which the emigrants brought upon those they had left behind. During this period I myself saw the pain and nostalgia of those who had emigrated and practically gone into exile. A song goes: 'The one who leaves doesn't forget: the one who stays always forgets.' Someone living abroad probably wrote it. Yet, this hitherto unacclaimed poetess forced me, through her verse, to realize the deep pain of those who had remained: their trauma was real even if they did not lose their fatherland in addition to their loved ones."

Two Worlds (New York:Pella Publishing Company, 1993. [By permission of Pella Publishing.]), a collection of Margaris' articles and short stories, was published posthumously by a committee composed primarily of members of the Hellenic Cultural Organization, chaired by the late Dr. Fotios Litsas. The stories were about the Greeks of Chicago and the Greeks of Asia Minor.

Theano Margaris' books represent only one part of her total literary output. Over a 50-year period she gave numerous lectures and wrote hundreds of articles for various Greek-American newspapers. Her short stories appeared in Athenian literary publications *Nea Estia, Argonautis, Smyrna,* and *Nea Epoche, Krikos* of London, and *Pyrsos* of Istanbul.

Here, Theano Margaris relaxes at home at 2224 N. Mulligan in Chicago, c. 1975, holding a copy of *Nea Estia,* a prestigious Athenian literary magazine that published many of her short stories.

Vivian Margaris Kallen, daughter of Theano Papazoglou Margaris, lives with her husband Arthur in Arlington, Virginia, where they are both active in civic and community affairs. A graduate of the University of Chicago with a Master of Arts in Social Science, Vivian is Professor Emerita of Political Science at Northern Virginia Community College in Annandale, Virginia. During her teaching career she received awards for her work as editor of the college's publication, *The Northern Virginia Review*, for spearheading the successful effort to create an honors program, and for her two terms as Chair of the five-campus College Senate.

In March 2000, Vivian was honored as a Person of Vision by the Arlington County Commission on the Status of Women, which praised her leadership in promoting educational equity for women as President of the Arlington Branch of the American Association of University Women and for her work on the Arlington County Commission for the Arts.

The Kallens have two sons: Jeffrey Leo, who teaches linguistics at Trinity College, Dublin, Ireland; and Gregory Margaris, an attorney in Big Stone Gap, Virginia. Their grandchildren are Esther Iphigenia of Dublin and Alicia and Seth Earle of Big Stone Gap.

Vivian learned to read and write Greek at Plato School of the Assumption Church in Chicago.

Four

VENETTE ASKOUNES ASHFORD (1906–1994)

BY NICHOLAS ASKOUNES ASHFORD, PH.D., J.D.

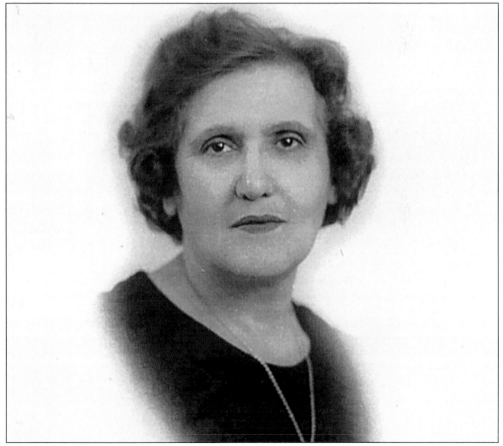

Venette Askounes Ashford was a distinguished social worker, teacher, and community leader. Esteemed because of her devoted work on behalf of the Greek immigrants of Chicago, she was known as the "Jane Addams of the Greeks."

Venette Askounes Ashford (nee Tomaras) was a distinguished social worker, teacher, and active member of the Greek communities of Chicago, St. Louis, and Tampa. She was born on May 3, 1906 in the seaport town of Filiatra, Greece. Her father, a customs officer and notary, died when Venette was three months old, leaving his wife and four children to fend for themselves. Though poor, as were many people in Greece at the time, Venette's mother also raised, as her own child, a girl who was abandoned on her doorstep in the village of Filiatra. Mrs. Tomaras was known to be kind and was a wet-nurse in the village. Venette Askounes credits her mother with teaching her the meaning of charity. In 1914, Mrs. Tomaras brought Venette and her adopted sister to the United States. Her three older brothers, Anthony, Chris, and John, had preceded them by a few years. Anthony had purchased a restaurant across the street from Hull House. On their second day in the United States, Anthony took Venette and her mother to Hull House to meet a "great lady," Jane Addams, in whose footsteps Venette was destined to follow. Jane Addams showed them great kindness and offered Mrs. Tomaras work on the looms at Hull House. Like many children of immigrants, Venette was thrust into a semi-adult role early in life, working in her brother's restaurant. An American patron of the restaurant urged Mrs. Tomaras to send her daughter to a private boarding school so that "she would not waste her brains." Though unable to read and write herself, Mrs. Tomaras grasped the importance of education and followed that advice.

Venette attended Wheaton College and Xavier College and graduated from DePaul University in Chicago in 1927. Venette became fluent in Greek, English, and French, and taught at Koraes Elementary School before turning to social work in 1932. She was among a handful of women of Greek descent receiving higher education at that time and was an early member of the Greek Women's University Club.

After graduation from DePaul in 1927, Venette began her career in social work by volunteering to work with immigrants at Hull House in Chicago. While at Hull House, Venette became a protege of Jane Addams, its founder. Encouraged by Addams, Venette received a graduate fellowship and attended the School of Social Service Administration at the University of Chicago. In 1932, Venette began her 30-year tenure with the Immigrants' Protective League (IPL) in Chicago, where she dedicated her professional life to helping immigrants adjust to the United States. The IPL was founded by Jane Addams in 1908, and its directors included Adlai Stevenson and Eleanor Roosevelt. The IPL provided a variety of constantly expanding social services to recent immigrants and eventually became a charitable organization, receiving most of its support from the Community Fund, complemented by contributions of the many ethnic groups it served. The Greek community was especially generous in raising money for the agency through its many social affairs. In 1948, Venette became a member of the Board of Directors of Hull House and throughout her career in Chicago received numerous awards from civic and community leaders.

What did Venette Askounes do for immigrants? First, it should be remembered that immigration laws did not favor those from the southern part of Europe. In 1924, immigration laws established quotas for immigration based on the percentages of peoples from other nations living in the U.S. as of 1890, thus disfavoring Greeks, Italians, and people from the Balkans. The Greek quota was 308 per year, and remained so for most of the next three decades. It was not until after the Second World War that more immigrants from eastern and southern Europe were allowed to immigrate to the United States. During her service to the community, Mrs. Askounes facilitated the immigration of over five thousand Greeks and, with her husband Theodore, personally sponsored hundreds of newcomers to the United States. Venette's son, Nicholas Ashford, recalls that a sympathetic immigration official in Chicago once said to her that he never met a person who had sponsored so many people. By the early 1950s, there were so many Greeks in Chicago that the city was often referred to as the third largest Greek city, after Athens and Thessaloniki.

Venette Askounes, however, did much more than sponsor immigrants. She found them jobs, encouraged them to go to school, helped them to obtain citizenship (without which jobs for some were impossible), and convinced them to help each other. A familiar pattern emerged.

An immigrant whom Mrs. Askounes sponsored, once here, would thank her and would say that there was no money to pay her office for its help. As her son Nicholas recalls, Venette would reply, "There is no need to pay me now; one day perhaps you can contribute to the office or I will ask you for a favor." But the favor would not be for herself. The favor she would ask of this immigrant five years later, when he owned a small restaurant, was to give a recent newcomer a job—or if he owned an apartment building with unoccupied units, an apartment for three months until the new family became independent. In this way, Venette created a network of community support for new arrivals from Greece.

In 1952, almost 38 years to the day she had immigrated to the United States with one living parent, Venette Askounes brought some 50 orphans to the United States as a social worker for the Immigrants' Protective League. As she had not returned to Greece since immigrating, this was a dual pilgrimage. All these orphans prospered in America. One of these orphans, Maria Zabaka, became the "adopted daughter" of Dr. and Mrs. Askounes, although she continued to keep in contact with her mother in Greece.

In 1933, Venette married the late Theodore Askounes Ashford, also an immigrant from Greece and a professor at the University of Chicago. Later he became a professor at St. Louis University and served as Dean of Sciences and Mathematics at the University of South Florida. Venette and her husband were active in the Greek War Relief effort in Chicago in the early 1940s. In St. Louis, to and from which she commuted in the 1950s while continuing to work in Chicago, she and her husband were active members of the St. Louis Greek community and were leaders in the Justice for Cyprus Committee. Venette took an active role in the formative years of the University of South Florida in Tampa.

She had three sons born in Chicago: Nicholas, Professor of Technology and Policy at MIT; Robert, Professor of Law at Syracuse University; the late Theodore, a composer, musician, and professor at Northwestern University and the University of Wisconsin; and her late daughter Maria Zabaka, an employee benefits specialist. Her husband and all her children were enthusiastically supportive of her work. She had four grandchildren: Nicholas, Venetia, Androniki Venetia, and Theodore III.

Venette Askounes' passing in 1994 marked the end of an era. She cared deeply about people and strove to ease human suffering. She was likely the first Greek professional social worker in Illinois, and perhaps the nation. It is no wonder that she was called, and is still regarded as, the "Jane Addams of the Greeks" by those Greeks who settled in Chicago.

Venette Tomaras is shown here as she appeared when she was a young teenager.

Venette Tomaras works in her brother Tony's restaurant across the street from Hull House in the early 1920s. Her brothers Tony, Chris, and John are the center three counter persons.

Venette Tomaras graduated high school from St. Mary's Episcopal Boarding School in Knoxville, Illinois, in 1923. One of the patrons of the family restaurant encouraged Venette's mother to send her daughter to school so she would not "waste her brains." She was one of the few Greek-American women who went to boarding school.

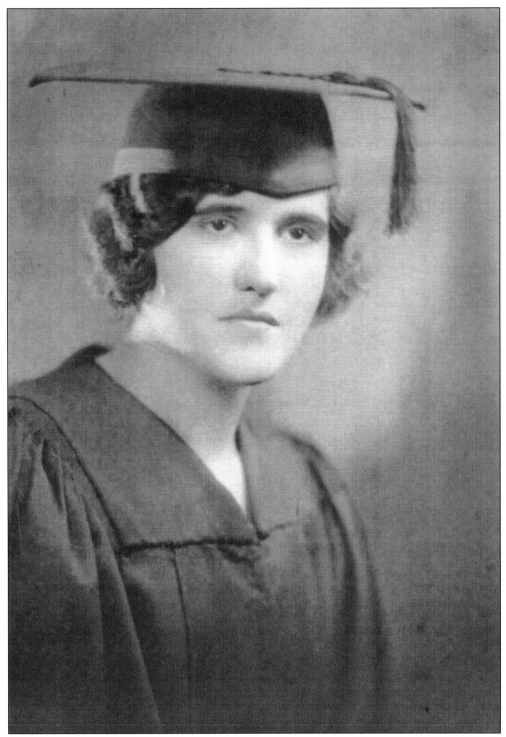

Venette Tomaras graduated college from DePaul University in Chicago in 1927. With the encouragement of Jane Addams, Venette later continued her education at the School of Social Service Administration at the University of Chicago.

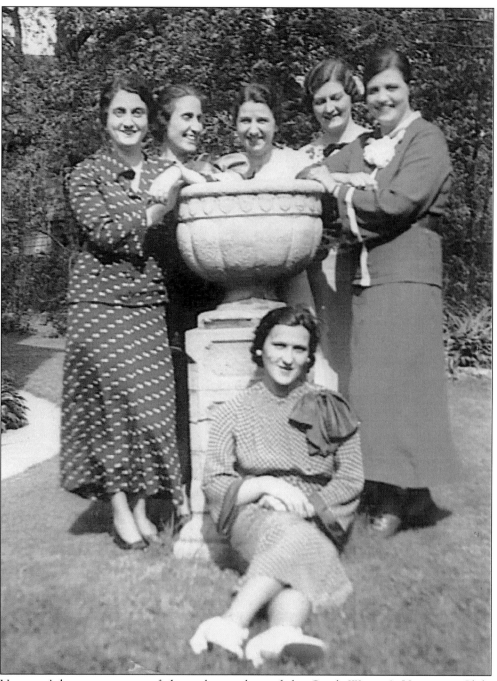

Venette Askounes was one of the early members of the Greek Women's University Club. Standing from left to right, are Barbara Petrakis Manta, Ellie Lambrakis, Sophia Diamant, Mary Maniaty Spanon, and Ione Kosmetos Soter. Venette Askounes is seated. The Greek Women's University Club was formed in 1931 to foster cultural and philanthropic activities and to encourage Greek-American women to obtain an education. In those years, very few women went to college. Some of the immigrants felt education for their daughters was not necessary, and that it might make them unmarriageable and/or ruin their reputations.

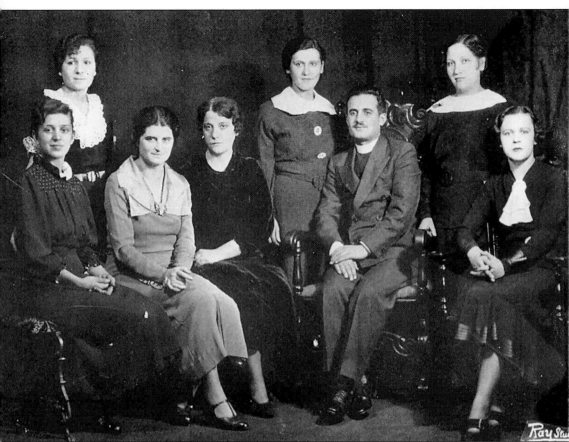

Venette Askounes was one of the faculty members in this 1935 photo of the faculty of the Koraes Elementary and Afternoon Greek Schools of SS. Constantine and Helen Greek Orthodox Church in Chicago. The faculty, headed by school principal Rev. Constantine Glenos, is shown here, from left to right, as follows: Marie Meets, Maria Koumendakis, Maria Christopoulou Sotos, Fotini Tanga, Venette Askounes, Demetra Lembesis, and Zoe Sigarou Toulepan. Venette Askounes taught Greek and English at the Koraes Elementary School. Parents sent their children to the Koraes Schools so that their children would retain their heritage by learning the Greek language, Greek culture, and Greek Orthodox religion.

This photograph of the family of Venette Askounes was taken in Chicago c. 1952. It includes Maria Zabaka, Robert, Theodore Jr., Venette, Theodore Sr., and Nicholas Askounes.

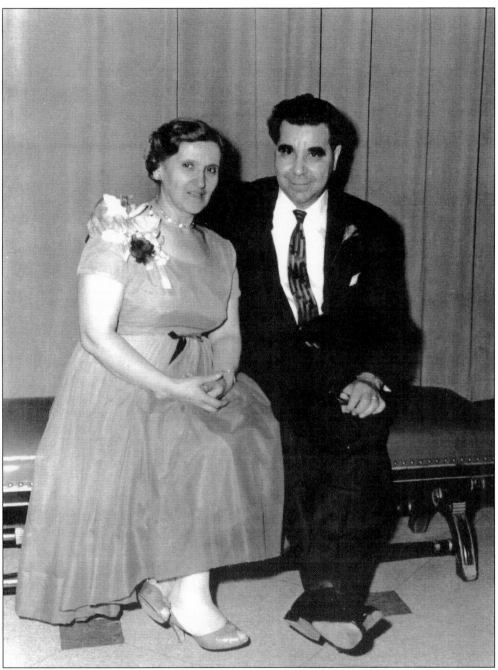

Here, Venette is with her husband, Professor Theodore Askounes Ashford. Professor Askounes, a Greek immigrant, added Ashford as a last name when he could not get work after receiving his Ph.D. from the University of Chicago. At that time, in the 1930s, prejudice against new immigrants was widespread. He looked in the phone book under the A's and chose the most "American" name near his own in the listings. The family used both the Greek and Americanized names.

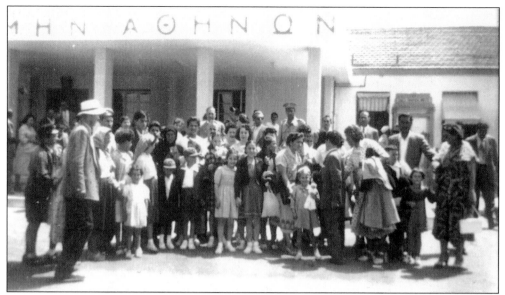

Venette Askounes, social worker for the Immigrants' Protective League, leaves Athens with approximately 50 orphans on June 11, 1952. This was Mrs. Askounes' first trip to Greece since her immigration 38 years before. The orphans ranged in age from babies to teens (some were old enough to have survived the awful conditions of World War II, the Occupation, and the Civil War). In Greece, a child was considered an orphan even if one parent was living.

Venette Askounes arrives with the Greek orphans in Chicago on June 11, 1952. One of the children in this group was Maria Zabaka, whose mother remained in Greece. Maria lived with the Askounes family, and the three Askounes sons welcomed her as a sister. She returned to Greece many times to see her mother.

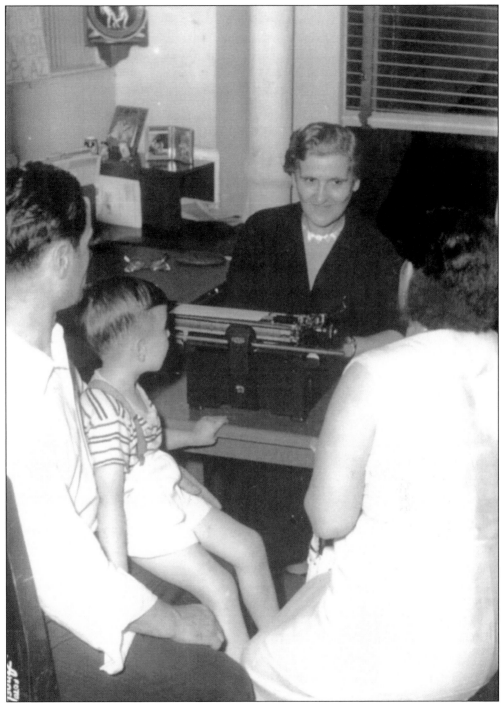

Venette Askounes works with an immigrant family at the Immigrants' Service League in Chicago in the early 1960s. Venette was known as the "Jane Addams of the Greeks." The Immigrants' Service League was formerly known as the Immigrants' Protective League, and is now known as the Heartland Alliance.

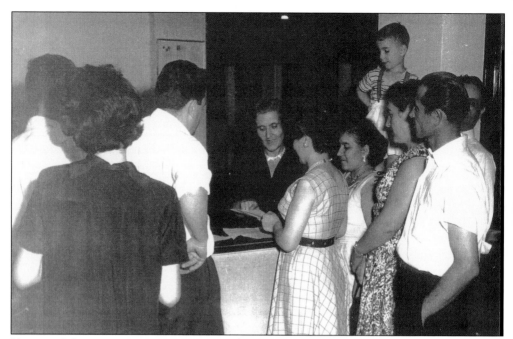

Venette Askounes assists newcomers at the Immigrants' Service League at Harrison and Dearborn Streets in Chicago, in the early 1960s.

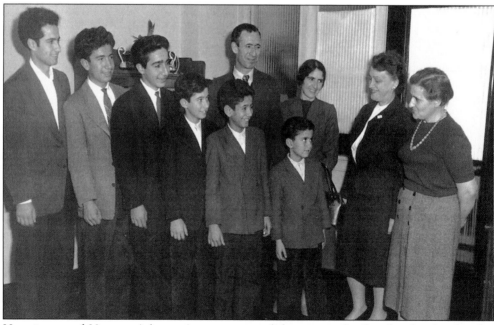

Here is one of Venette Askounes' many accomplishments: a family of eight shortly after their arrival in the United States in the 1950s (with Ione DuVal, Director of the Immigrants' Protective League, at right). From 1924 until after World War II, immigration from Greece virtually ceased. After World War II, in the 1950s under the Displaced Persons Act, Greek immigrants from war-torn Greece started immigrating again. According to Dr. Nicholas Ashford, their son, Dr. and Mrs. Askounes personally sponsored hundreds of Greek immigrants.

OFFICE OF THE MAYOR
CITY OF CHICAGO

RICHARD J. DALEY
MAYOR

September 9
1 9 5 9

Greek Immigrants Committee
 of the State of Illinois
641 South Elgin Street
Forest Park, Illinois

Dear Friends:

 I have learned that special recognition
and honor should go to Mrs. Vanette Askounes for her
untiring years of service to the Immigrants' Service
League. Since 1932 Mrs. Askounes has rendered service
to Greek immigrants who come to the United States. In
doing this, she has expressed the true spirit of America
which is one of welcome and understanding to people of
all nations who come here to live with us.

 In addition to what Mrs. Askounes has done
for the individual immigrants who have come to the
United States, she has rendered a great service to this
city, as well as our country, in providing for them the
hospitality and friendship which everyone needs when
they leave their homes where they have roots and friends.
The labor of love for those who come to a strange land
can only be provided by a woman like Mrs. Askounes, who
understands the need for friendship and help for new-
comers to our community. The citizens of our community
are grateful to her.

Sincerely,

Mayor

Venette Askounes received this letter of appreciation from Mayor Richard J. Daley in 1959.

The Greek Committee

to Aid the

Immigrants' Service League

Presents its

Twentieth Annual Dance

at the S. J. GREGORY AUDITORIUM

SATURDAY EVENING, JULY 9, 1960

8:30 P.M.

THE GREEK COMMITTEE

to Aid the

IMMIGRANTS' SERVICE LEAGUE

Mrs. Theodore Askounes, Executive Secretary

1960 COMMITTEE MEMBERS:

Miss Bertha Barounis	Mrs. Joan Kent
Mr. George Carayannis	Mr. Antonios Koclanakis
Mrs. Nona Commodore	Miss Aglaia Kotsiopoulos
Mrs. Alexandra Dragonas	Mrs. Mathew Manaves
Miss Katherine Floros	Miss Demetra Maniatis
Mr. Anastasios Gravilos	Miss Electra Milonas
Miss Elaine Georgas	Mr. Seraphim Papajiannis
Mrs. Harriet Glikis	Mr. Demetre Papangelou
Mr. Peter Gountanis	Mr. Basil Portocalis
Mr. John Hamel	Mrs. A. Spirides
Mr. Yani Izvinko	Mr. A. Vasilopoulos

SPONSORED BY:

Mr. George Annes	Dr. Basil Photos
Mr. Louis Djikas	Mr. Michael Krokidas
Mr. Thomas Gialamas	Mr. P. Vasilopoulos
Mr. Peter Gianukos	Mr. John L. Manta
Mr. James Glyman	Mr. Arthur Papanton
Mr. James J. Gregory	Mr. John H. Papas
Mr. S. J. Gregory	Mr. Demetri Parry
Mr. George Kokalis	Mr. George Phillips
Mr. Gust Koretos	Mr. James Photakis
Mr. Peter Spartin	Mr. Peter Xinos

IMMIGRANTS' SERVICE LEAGUE

OFFICERS:

MR. GEORGE F. SISLER President
MR. LEWIS J. SILVERMAN Vice-President
MR. JOSEPH POIS Vice-President
MRS. JAMES H. BECKER Secretary
MR. DAVID M. SWEET Treasurer

STAFF:

MRS. IONE A. DU VAL Director
MISS HELEN B. JERRY Attorney
Mrs. Venette Askounes Mrs. Elizabeth Kraulis
Mrs. Gerda Meyer

BOARD MEMBERS:

Mr. Benjamin S. Adamowski	Mrs. Joel Goldblatt
Mr. Hugo Anderson	Mrs. Daggett Harvey
Mr. John L. Antognoli	Mr. J. Ross Humphreys
Mrs. Robert M. Atwater	Mr. Christopher G. Janus
Mr. Joseph H. Beuttas	Mrs. Arthur S. Kahn
Mr. Augusto G. Borselli	Mrs. Alfred D. Kohn
Mrs. C. Wayland Brooks	Mrs. Lloyd Lewis
Mr. J. Beidier Camp	Mr. Lawrence L. O'Connor
Miss Helen C. Campbell	Mr. Conrad A. Orloff
Miss Elizabeth Cheney	Mr. Demetri Parry
Mr. Fairfax M. Cone	Mr. Robert Pollak
Mrs. Edison Dick	Mr. Lee Schooler
Mrs. Edward Park Doyle	Mrs. Edward B. Smith
Mrs. Ruth Gaylord	Mr. Leonard Spacek
Mr. Otto Geppert	Mrs. David B. Wallerstein
Mr. Adlai E. Stevenson	

This is the program book for the Twentieth Annual Dance of the Greek Committee to Aid the Immigrants' Protective League. The generous Greek-American community raised many thousands of dollars for this cause.

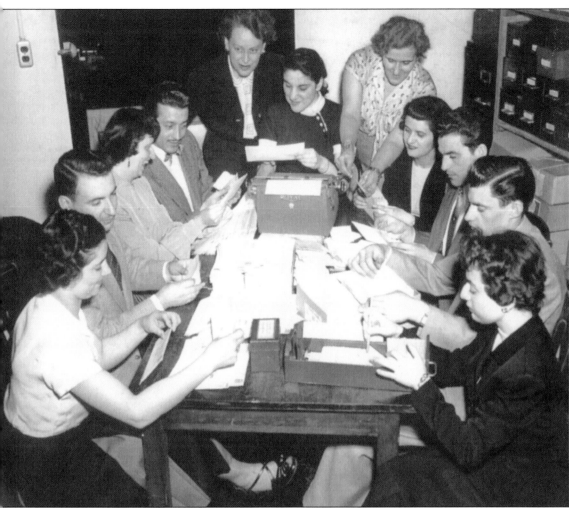

Staff and volunteers work hard for a fund raiser organized by the Greek Committee to Aid the Immigrants' Protective League, c. 1954. Included, from left to right, are the following staff and volunteers: Angeliki Vardalou, Peter Spartin, Anne Avgerinos, Andrew Spyropoulos, Ione Agnew Duval (Director of the Immigrants' Protective League), Electra Milonas (Tarsinos), Venette Askounes, Betty Salopoulos, Bill Bokos, and Christ Demos.

Venette Askounes appears with Adlai Stevenson (to her left) at one of the many annual fund raisers of the Greek Committee to Aid the Immigrants' Protective League in Chicago. To the far left is Stephanos Rocanas, Consul General of Greece, and John L. Manta. The man on the right is not identified. This photo was taken in the 1950s.

Venette Askounes plays the piano at a fund raiser of the Greek Committee to Aid the Immigrants' Protective League. The outer persons are unidentified. The inner persons are Venette's sons, Nicholas and Robert, her husband Theodore, her son Theodore Jr., and Electra Milonas Tarsinos.

Ione Agnew DuVal (Director of the Immigrants' Protective League) and Venette Askounes dance Greek at a fund raiser of the Greek Committee to Aid the Immigrants' Protective League.

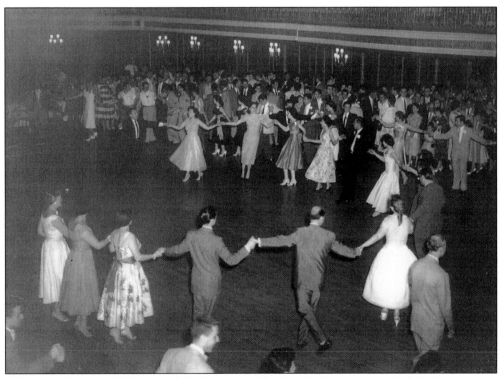

This is another one of the annual fund raisers of the Greek Committee to Aid the Immigrants' Protective League.

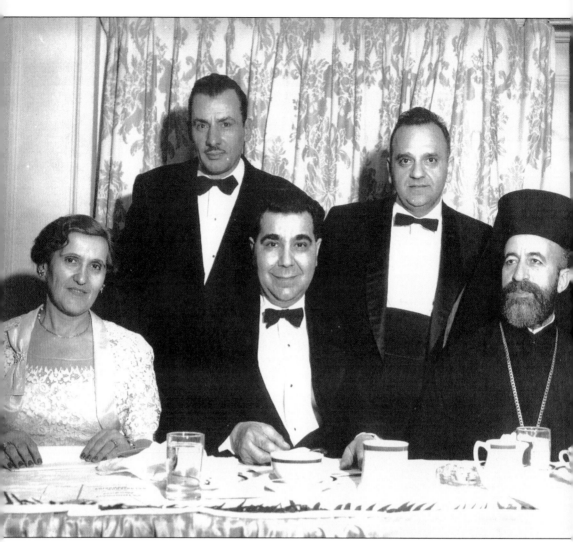

Venette and Theodore Askounes, Archbishop Makarios of Cyprus, Gus Koukoulis, and Nicholas Matsakis are in St. Louis, Missouri, at a fund raiser given by the St. Louis Justice for Cyprus Committee in 1957. At that time the Justice for Cyprus Committee was interested in helping the Cypriots, then under British rule, to become united with Greece. The Askouneses were active in this cause. The Askounes family moved to St. Louis after Professor Askounes accepted a position in the chemistry department at St. Louis University. Venette, dedicated to helping the Greek immigrants, commuted to Chicago and stayed four days a week to continue her work at the Immigrants' Protective League.

Venette Askounes and her daughter-in-law Mary enjoy the garden of the Askounes home in Tampa, Florida in 1970. Venette Askounes accompanied her husband to Florida when he took a position as Dean of Sciences and Mathematics at the University of South Florida in 1960.

Nicholas Askounes Ashford, Professor of Technology and Policy at the Massachusetts Institute of Technology, is the eldest son of Theodore and Venette Askounes Ashford. At MIT he teaches courses in Environmental Law and Policy; Technology, Law and Public Policy; and Sustainability, Trade and Environment.He holds both a Ph.D. in chemistry and a Law Degree from the University of Chicago, where he received graduate training in economics. He graduated from Washington University, St. Louis with a B.A. in chemistry. Dr. Ashford is an accomplished oboist and jazz bassist and played with the Greek Lads when he was in Chicago.

Professor Ashford is the author of a major work for the Ford Foundation, *Crisis in the Workplace: Occupational Disease and Injury*. He has co-authored three additional books: *Monitoring the Worker for Exposure and Disease*; *Technology, Law and Working Environment*; and *Chemical Exposures: Low Levels and High Stakes*. He was a public member and chairman of the National Advisory Committee on Occupational Safety & Health, served on the EPA Science Advisory Board, and served as chairman of the Committee on Technology Innovation & Economics of the EPA National Advisory Council for Environmental Policy and Technology. Dr. Ashford is a fellow of the American Association for the Advancement of Science and serves as an advisor to the United Nations Environmental Programme. He was recently appointed to the US-Greek Council for the Initiative on Technology Cooperation with the Balkans.

Five

STATE SENATOR ADELINE J. GEO-KARIS (1918–)

BY ELAINE COTSIRILOS THOMOPOULOS, PH.D.

Senator Adeline J. Geo-Karis has served with distinction in the Illinois State Legislature since 1972. She currently is Assistant Majority Leader of the State Senate. She states, "If I have been at all successful in life I owe it to the great values instilled in me by my parents, to God's many blessings, and to the opportunities that this great country of America made available to me."

Adeline J. Geo-Karis, LL.B., was born in the farming region of Tegea, Greece on March 29, 1918. She was the youngest of ten children, six of whom had died before she was born. Her mother and father's marriage was unusual in a time when marriages were arranged. She explains, "My mother and father eloped with the whole village knowing about it. She was 17. He was 21. He worked in her fields."

Her father, John, immigrated to the United States in 1898. A few years later he brought his wife, Theofani Navlaris Geo Karis, to the United States where their son Nicholas was born. The family went back to Greece in 1915. Five years later, in 1920, her father, accompanied by Adeline's two older brothers, Alex and Nick, returned to the United States.

Four-year-old Adeline, her mother, and older sister Toula arrived in the U.S.A. on the Fourth of July, 1922. She recalls, "I was the only family member on deck as the Big Lady (the Statue of Liberty) became visible, because my mother and sister were seasick and too ill to watch as the ship entered the harbor. The passengers were crying. It was a sight I will never forget. I remember saying to myself, "'She must be a very important lady!'" She relates her first impressions of America:

I came to America through Ellis Island. I hated the place. The windows were so high. I couldn't see out, and I was used to roaming around in my fields in Greece. The first word I learned was ice cream. And we learned to speak English without a bilingual education. We learned it fast. My favorite person was a policeman in his navy blue uniform who used to take my hand and cross the street with me. And that's why I have the highest regard for law and order.

The family settled in Chicago, where her father had established himself in the wholesale banana business. As a child Adeline was an excellent student and loved to read. She especially liked the Horatio Alger books. She says, "Because my mother started to think I was reading dirty books, I started to hide them under the stairs. . . They were very inspirational for me. . . those books made me think that I could accomplish things. I could do things no matter what."

Although her parents were not in favor of her going to college, Adeline, an honor student, loved school and was determined to continue. She explains, "In those days it was unusual for a Greek woman to go to college. In fact Greek-American women were not even encouraged to go to high school. . . One of my family's friends told my mother, 'Don't send her past grammar school.'"

Another family friend, Adam Porikos, encouraged her mother to let her go to college, saying, "Your daughter is a very intelligent girl. Why don't you let her go on?"

Adeline Geo-Karis started her political career early, as an elected student representative at Austin High School in Chicago (where she rebelled against no soap in the bathrooms) and as senior class president at Theodor Herzl Junior College in Chicago. She completed her LL.B. degree at De Paul University in 1942. As she recalls, "There were about 400 students in the day and night school in DePaul University Law School and about 35 women. When I was graduated, there were only 120 students in my class and I was the only woman. I don't know how I did it because I'll tell you it was tough. But I managed. . . I was working my way through school then."

Of her decision to pursue a law degree she relates:

Being the youngest in my family, and a female at that, it took a staggering amount of trail-blazing to convince them of the propriety of my intention to become a lawyer. Their volatile Mediterranean style of responding to this ambition would have shaken to the foundation anyone of weaker constitution. They could conceive of a woman being a teacher of law, but certainly not an attorney.

Geo-Karis was the second Greek woman to become a lawyer in the State of Illinois. (The first was Koula Butler.) She distinguished herself throughout her career, and was an inspiration and role model to women who followed.

Adeline worked to pay her way through school at various jobs, as a receptionist in a furrier's store, selling women's lingerie, and at a factory. She gleefully relates her experience in the factory:

They thought they'd play a nice trick on me. . . . The chief tester puts the biggest, fattest cockroach you ever saw in your life in my machine. They expect, this college student, I was the only college student there, to scream and I didn't. I looked at it, found out who put it here, and I waited. And then I put the big, fat cockroach (when he was out to lunch), opened up his center drawer and stuck it right there, then just went back to my job. I tell you one thing. He had the healthiest respect for me. And he and I are still good friends.

Adeline enlisted in the Navy in 1942. She says:

I never lied to my parents. I said, 'I've applied for a government job'. . . . I did go for a government job. It was in the Navy. So that night I told 'Aunt' Mary Soundris (Saunders) what I did, in front my Mom and Dad. And my mother said, 'You did what!' I said, 'I joined the Navy.' And Mrs. Soundris says, 'What's wrong with it, Theophani? That's terrific. Afto einai polli kallo. . . Kallo ekanes.'

Adeline describes the years she spent in the Navy from 1942 to 1946 as "the most fruitful years of my life." She started as an apprentice seaman and rose to the rank of lieutenant commander with top-secret clearance. She was one of the first female lawyers in the Navy's Judge Advocate Corps. Of her experience in the Navy she says, "I love the Navy. It had a tremendous influence. From my experience with the Navy, I learned that there was no substitute for truth and perseverance."

She returned to Illinois in 1946 and settled in Zion, where she started her law practice. In 1946 she also did post-graduate work in political science at Northwestern University. Regarding her decision to settle in Lake County after the service, she told her father, "Dad, I'm going to settle in a small town and start from scratch. You did it when you came to this country . . . You didn't have anyone really helping you. So, if you could do it, I can do it. At least I have an education." Independent and determined, Adeline did succeed. She established a respected law firm in Zion and continues to head this firm today. She currently represents Vernon Hills, and formerly represented Mundelein, Libertyville Township, and Long Grove School District.

In 1949, she was elected justice of the peace and in 1958 she was appointed as assistant state's attorney. Elected to the Illinois House of Representatives in 1972, she served there for six years. In 1978, she was elected to the Illinois Senate and continues to serve in that capacity. She reports that one of her proudest accomplishments in the Senate was the passage of legislation regarding needed change in the rape laws so that perpetrators do not victimize victims.

The community of Zion elected her mayor in 1987, and she remained in that position until 1991. Senator Geo-Karis is currently co-chairman of the Republican Party for Lake County.

Senator Geo-Karis blazed many trails in politics over the past half-century. The first woman in the entire state to serve in a leadership role in the Senate, presently she is assistant majority leader for the Republican Party and has served in that capacity since 1992. She is the first Lake County woman to achieve the following positions: justice of the peace, assistant state's attorney, Illinois State Representative, and Illinois State Senator. She has contributed her talent to various community organizations including the Red Cross, Easter Seals, American Legion Lake County Women's Post #1122, Am Vets Little Fort Chapter 35, OES Milburn Chapter #570, American Association of American Women, Altrusa Club, Zion Chamber of Commerce, Zion Women's Club, Zonta Club, and American Businesswomen. She is a lifetime member of the Navy League.

Senator Geo-Karis is also a leader in her ethnic community and church. In the 1930s, she was an early member of the Greek Women's University Club, and she continues her membership today. From 1947 to 1972, she directed the church choir at St. Demetrios Church Greek Orthodox Church in Waukegan. In 1962, she was elected president of St. Demetrios Greek Orthodox Church Philoptochos, a women's organization. She was elected president of the parish council at that church in 1968. In those days, she was one of the few women in the United States to have such a position. From 1953 to 1955, she was the Grand President of the Daughters of Penelope, the women's auxiliary of the American Hellenic Educational

Progressive Association (AHEPA), a Greek-American national organization. During her presidency, at the suggestion of Dorothea Chappen (a fellow member from New Jersey), she organized a successful drive to enable military personnel to have the Greek Orthodox religion recorded on their dog tags.

Senator Geo-Karis recalls, "When I immigrated here as a young child I missed Greece, the beauty of the countryside. When I told my father I wanted a ship to take me back, he disappointed me by giving me a gift of a toy ship. Soon I adjusted and now I love this country!" Senator Geo-Karis has shown her love of this country by helping countless people through her kindness, perseverance, honesty, and leadership. She has served her country well.

Senator Adeline Geo-Karis, a woman of distinction, has received numerous awards, including the Americanism Medal from the North Shore Chapter, D.A.R., The Daughters of Penelope Women of the Year Award, the Illinois Federation of Independent Colleges and Universities Outstanding Legislator Award, the Illinois Association of Park Districts Award, the Jane Addams Leadership Award, NAACP Award from the North Chicago Chapter, YWCA Award of Lake County for Outstanding Achievement in Government, the Most Distinguished American of Greek Ethnic Origin in the Field of Government by the United Hellenic Voters of America, the Carrie Chapman Catt Award from the Illinois Women's Political Caucus, the Greek-American Community Services Heritage Award, Greater Waukegan Israel Bond Rally Honoree, Illinois State's Attorney's Legislative Award, Military Order of the Purple Heart Award, Midwestern Regional Medical Center Award, and Friend of Business LUCI (Leading Us in Commerce and Industry) Award.

This marvelous woman who has devoted her life to serving others says, "If I have been at all successful in life I owe it to the great values instilled in me by my parents, to God's many blessings, and to the opportunities that this great country of America made available to me."

(*Sources: Oral history of Senator Geo-Karis*, 1997, conducted by Elaine Cotsirilos Thomopoulos, recorded by John Kulidas and transcribed by Georgia Vlahos. Also, documents provided by Senator Geo-Karis and *Who's Who in America, 1999* New Providence, R.I.: Reed Elsevier, Inc., 1999.)

This photo of Senator Adeline Geo-Karis was taken in the 1970s.

Senator Geo-Karis is pictured as a young child of four or five, shortly after immigrating to the United States from Tegea, Greece in 1922.

Senator Geo-Karis directed the St. Demetrios Greek Orthodox Church Choir of Waukegan from

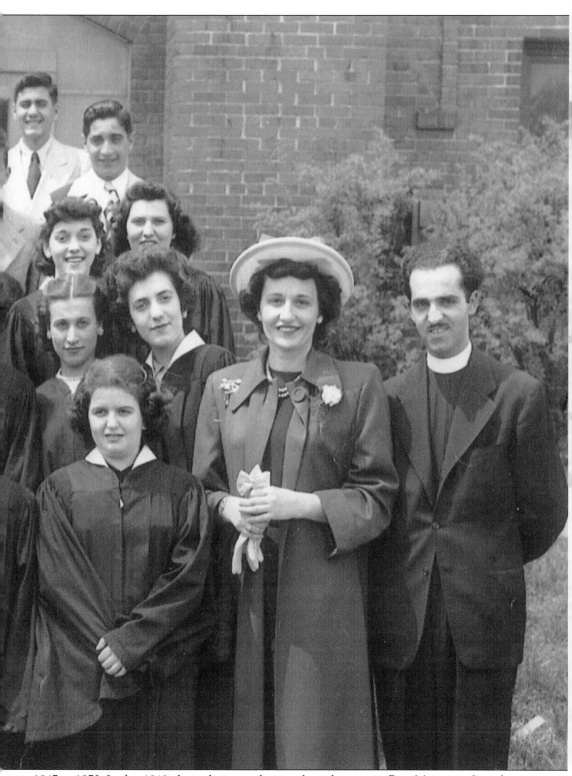

1947 to 1972. In this 1948 photo she is standing on the right, next to Rev. Manoussos Lionakis.

From 1942 to 1946, Senator Geo-Karis served in the U.S. Navy where she started as an apprentice seaman and rose to the rank of lieutenant commander with top secret clearance. She was one of the first female lawyers in the Navy's Judge Advocate Corps. Of her experience in the Navy, she says, "I love the Navy. It had a tremendous influence on my life. From my experience with the Navy, I learned that there is no substitute for truth and perseverance."

From 1953 to 1955, Senator Geo-Karis served as the Grand President of the Daughters of Penelope, the women's auxiliary of the American Hellenic Educational Progressive Association (AHEPA), a national organization. During her presidency, at the suggestion of Dorothea Chappen, a fellow member from New Jersey, she organized a successful drive to enable military personnel to have the Greek Orthodox religion recorded on their dog tags. (Photo courtesy of the AHEPAN Magazine.)

1953-55
Hon. Adeline Geo-Karis

This photo was printed in the *Greek-American Community Services' Heritage Award Book* of April 22, 1988, the date Geo-Karis received the GACS Heritage Award.

Senator Geo-Karis stands, fourth from the right, along with other Heritage Award recipients, officers and friends of GACS, in this photo taken at the GACS Heritage Award celebration in 1988 at the Fountain Blue Restaurant in Des Plaines, Illinois.

These two photos show Senator Geo-Karis participating in parades in Lake County. She has served Lake County for many years as an assistant state's attorney, state representative, state senator, and mayor of Zion.

Senator Geo-Karis shows her support for Girl Scout Troupe No. 356 of Zion, Illinois. For two years, the troupe went to schools and performed a program on drug and alcohol prevention. The senator attended their first performance in October of 1988.

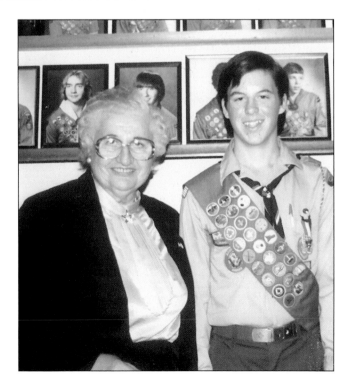

Senator Adeline Geo-Karis and Keith Alan Peacy are pictured in 1987 at his Eagle Scout Ceremony in Zion, Illinois.

Governor James Thompson swears in Senator Geo-Karis as mayor of Zion in 1987. She served as mayor of Zion until 1991.

To "Geo" Geo-Karis with best wishes *Gy Bush* + *Barbara Bush*

Senator Geo-Karis is shown here with former President George Bush and former First Lady Barbara Bush. She served as co-chair for "Greeks for Bush" in the 1988 presidential election campaign.

Senator Geo-Karis has served in the Illinois State Legislature since 1972, first as a state representative and then as state senator. She has been assistant majority leader of the senate since 1992.

CONCLUSION

The women featured in this book were exceptional women who contributed immeasurably to our society through their dedication, intelligence, perseverance, and organizational abilities. At the turn of the century, few of the men and women who immigrated here had even completed grammar school; many were illiterate. These five women had the advantage of education. Georgia Pooley and Presbytera Stella Petrakis attended high school in Greece. Theano Margaris, although she had attended only grammar school, was an avid reader who was self-educated. Two of the women, Venette Askounes and Senator Adeline Geo-Karis, completed college as well as graduate courses in the United States of America, even though it was unusual at that time for a Greek-American woman to go to college.

Each of them used her education and intelligence to preserve the Greek heritage and Greek Orthodox religion in this country. They also organized efforts to help Greece, their country of birth. Georgia Pooley organized a pan-Orthodox religious organization and was active in the Greek War Relief of World War II. Presbytera Petrakis directed Greek-American theater groups that put on religious and Greek patriotic plays and organized the afternoon Greek school at SS. Constantine and Helen Greek Orthodox Church. She also founded women's philanthropic church clubs and Amalthia, a Cretan women's group. She was involved in fund raising for a variety of causes in Greece, such as the 1923 fund raiser to help the war orphans of Greece and the Greek War Relief Association of World War II. She was also an active member of the Justice for Cyprus Committee. Venette Askounes taught at the Koraes School of SS. Constantine and Helen Greek Orthodox Church. She was active in the Greek Women's University Club and the Justice for Cyprus Committee. Theano Margaris explored social issues in Greece and the United States and kept the Greek language alive through her theater work and her books and articles. Senator Geo-Karis was active in the Greek Women's University Club, was director of her church choir, and president of her parish council. As president of the Daughters of Penelope, a national Greek-American organization, she was instrumental in lobbying to allow Greek Orthodox servicemen and servicewomen to wear dog tags indicating their religion. Senator Geo-Karis also helped the Greek War Relief and Justice for Cyprus Committees.

They assisted thousands of immigrants with the difficult adjustment to life in the United States and guided them in becoming citizens. Georgia Pooley, Presbytera Stella Petrakis, Venette Askounes, and Senator Geo-Karis were revered because of their wise and kindly counsel. By effectively using a network of organizations and individuals in the Greek and American communities, they helped immigrants find work, a place to live, or money to pay the rent or medical bills. They cut through the red tape of the immigration office. Venette Askounes was

able to offer her services through the Immigrants' Protective League and personally sponsored hundreds of new immigrants. Senator Geo-Karis continues to lend a helping hand through her political activity, her legal expertise, and her contacts in government service and the community. She has quietly counseled many young people against drugs and alcohol.

Theano Margaris, a wise and sympathetic woman, reached the Greek-American immigrants through her weekly columns, books, theater, and lectures. By drawing upon her own experiences, she touched the soul of her audience. For six years she had her own weekly "Women's Page" where she wrote short pieces on child care, cooking, and nutrition as well as about women's rights and the importance of educating daughters as well as sons. "One of the purposes of my writing," she said, "was to help the immigrants in adjusting to this new country." She understood the difficulties of living in a strange and alien culture, but she also communicated her love for America. Vivian Kallen, her daughter, recalls her saying, "If America had taken in only the educated and wealthy, it wouldn't have been a great accomplishment. It's because she took in people for whom America was the last hope that America is so great."

Each woman was a vibrant force in the American community. Presbytera Petrakis organized Red Cross units and remained active in the Red Cross for more than 60 years. She sold U.S. War Bonds during World Wars I and II, served on the board of an interfaith women's council, and volunteered at hospital auxiliaries. Mrs. Askounes worked for the Immigrants' Protective League and served on the Hull House Board of Directors. One of Mrs. Margaris' concerns was unfair labor conditions in the United States. Senator Geo-Karis continues her more than 28 years of public service as a respected Illinois legislator, as well as being active in a number of community organizations such as the Red Cross, Easter Seals, American Legion, AmVets, American Association of American Women, Navy League, American Businesswomen, and Zion Chamber of Commerce.

Axion, worthy or meritorious, describes these five women, but each of the thousands of women who immigrated to Illinois from the poor rural villages in the early part of the 20th century could be called *axion* as well. Very few were professional women; most never graduated from grammar school, and there were many who were illiterate even in the Greek language. The language and cultural barriers that they encountered in America must have seemed insurmountable. Scared and lonely they were, but strong! They were determined to make a new way of life in the United States, leaving behind the beauty but also the poverty of their beloved Greece. And they did make a new and better way of life! They took the best of their Greek heritage and the best of what they found in America to forge their proud new identity as Greek-Americans.

The few who worked outside the home most likely labored in restaurants and stores alongside their husbands. The energies of the early immigrant women were concentrated in the home and church. They raised their families and labored long hours in cooking delicious food, cleaning the home, sewing the clothes, and doing beautiful embroidery, crocheting, and knitting. Their efforts built the churches and established community organizations. With discipline and tenderness, they nurtured their children and their children's children. Their children and grandchildren are today's doctors, scientists, engineers, lawyers, artists, educators, and entrepreneurs—leaders of our community.

Despite overwhelming hardships in the early years, these courageous immigrant women built a loving community and left a wonderful legacy. Heroines all!

Elaine Cotsirilos Thomopoulos, Ph.D.
2000